IMAGES
of America

PASO ROBLES

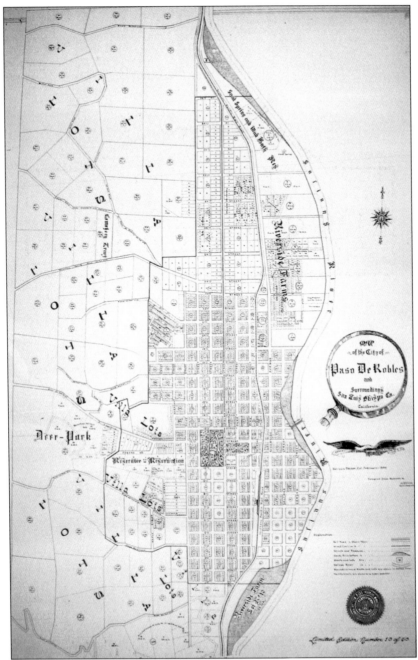

This 1909 map shows Paso Robles to the west of the Salinas River. The mud-bath springs are to the north, and the larger dark rectangular area near the center represents the Hotel El Paso de Robles grounds. The main thoroughfare through town, El Camino Real, passes between the hotel grounds and the city park (the other dark rectangular area). The hotel's main sulfur spring was due south of the park. (Courtesy Paso Robles Historical Society.)

ON THE COVER: This 1947 parade entry for the annual Pioneer Day celebration in Paso Robles epitomizes the area's agricultural heritage. (Courtesy Judy Holsted.)

IMAGES
of America
PASO ROBLES

Andrea H. Hobbs and Milene F. Radford
Paso Robles Pioneer Museum

ARCADIA
PUBLISHING

Copyright © 2007 by Andrea H. Hobbs and Milene F. Radford, Paso Robles Pioneer Museum
ISBN 978-0-7385-4721-3

Published by Arcadia Publishing
Charleston SC, Chicago IL, Portsmouth NH, San Francisco CA

Printed in the United States of America

Library of Congress Catalog Card Number: 2006935608

For all general information contact Arcadia Publishing at:
Telephone 843-853-2070
Fax 843-853-0044
E-mail sales@arcadiapublishing.com
For customer service and orders:
Toll-Free 1-888-313-2665

Visit us on the Internet at www.arcadiapublishing.com

For information about the Paso Robles Pioneer Museum, write the Pioneer Museum at P.O. Box 461, Paso Robles, CA 93447; or visit www.PasoRoblesPioneerMuseum.org.

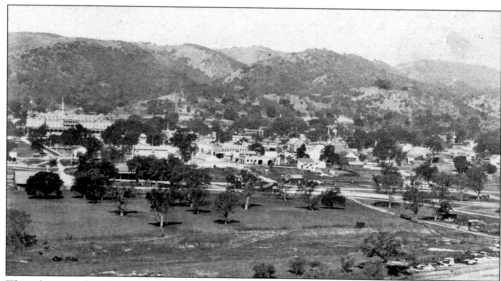

This photograph, taken around 1900, shows Paso Robles nestled between the Salinas River and the oak-covered rolling hills to the west.

CONTENTS

ACKNOWLEDGMENTS

This publication was made possible through our sponsor, the Paso Robles Pioneer Museum, and its treasure trove of images and ancestral records—a welcome resource for historical research. The images used without credit lines are from the museum's collection of photographs, which have been donated through the years by numerous families and individuals, including Swift Jewell's family (Pioneer Day photographs), Judy Holsted (Pioneer Day photographs), Paul Kinne (Paso Robles Trail Riders photographs), Lewis Slate (Cal-Al photographs), Joan Crother, and many others. The Pioneer Museum's images were augmented with images from many longtime local residents who opened their photograph albums to us.

We are very grateful to the following who loaned photographs, answered questions, supported, and encouraged us: Barbara Bilyeu (research librarian, Paso Robles Public Library); Hy Blythe; El Paso de Robles Area Historical Society; Dennis Judd (history instructor, Cuesta College); Dorothy "Dot" Lefebvre (1890 House); Norma Moye (executive director, Downtown Paso Robles Main Street Association); Bonnie Nelson (collector of local postcards); Harold Franklin and Wallace "Wally" Ohles (local historians); Gary Smith and his cousin Nancy Wimmer Bodendoerfer (keepers of their grandfather Clark S. Smith's extensive photograph collection); and the many others who contributed in immeasurable ways.

A huge thank you goes to Karl Von Dollen for his computer expertise and the countless hours he spent scanning photographs. A big thank you also is extended to Doug and Kathy Schultz of The Blueprinter, who scanned images. A gigantic thank you goes to Carilyn Anderson for the myriad hours she spent engaged in editing the text.

We are very appreciative of our husbands, who were ever so patient while we spent multitudinous hours working on the publication.

INTRODUCTION

For thousands of years, Salinan Indians enjoyed the abundant thermal springs located in the oak woodlands of the central coast of California, including the area now known as El Paso de Robles (The Pass of Oaks). Under the direction of Franciscan friars, the Salinans built nearby Mission San Miguel, grew crops, and raised cattle. From the local people, the friars learned the benefits of the healing springs. Following Roman Catholic doctrine, other missions within a day's walk (San Antonio and San Luis Obispo) had also been built to evangelize Salinans and Northern Chumash. Starting in the mid-1800s, industrious settlers from Europe, the Midwest, and the East began to arrive and establish farms in the area, joining the Native American, Spanish, and Mexican people who were already living here. Coming to earn their living off the land and to raise their families, the settlers raised poultry, sheep, cattle, pigs, grain, and grapes and planted walnut, almond, and fruit trees. The plentiful natural hot springs and mud baths undoubtedly provided welcome relief from their strenuous endeavors. Many of the settlers added to the Judeo-Christian influence of the area and established some of the first Protestant churches: Methodist, Presbyterian, Christian, Baptist, Episcopal, Congregational, Lutheran, and Mennonite. The hard-working pioneer families shaped the character of the new community.

Farming was filled with many headaches, but in spite of often backbreaking and fruitless endeavors, the pioneers persisted. Some thought the advertisements that brought them to the area might have touted too many benefits. Dry-farming was challenging. When rain was almost nonexistent in the 1880s, it was devastating to the pioneers. Yet most of the families who stayed and persevered thrived.

The railroad was a significant factor in bringing growth and vitality to Paso Robles. By 1886, Chinese workers had built the tracks from Soledad to Paso Robles. This new transportation made faster and farther-reaching shipments of farm products possible. As the railroad enabled more trade (although at high prices), farmers and ranchers brought their goods to town to store in warehouses until the goods could be sent on. With increased activity in the town, enterprising individuals developed businesses to provide for the new needs. Names such as Anderson, Bell, Cuendet, Heaton, Henderson, Lundbeck, Smith, Wright, and many more contributed to the commerce of the new community.

Once the railroad was in place, Daniel D. Blackburn and Drury James (uncle of Jesse James) saw the great potential for growth and decided to expand their private village into a full-fledged town. The men dreamed of an elegant city with the hot sulfur springs as the predominant attraction. They sold lots and gave the town a two-block park, which became the heart of the town, across the street from the hotel. In 1891, Blackburn and James completed a three-story showpiece, Hotel El Paso de Robles, which became a major attraction for travelers. Paso Roblans will always remember the Pittsburgh Pirates, who were headquartered at the hotel during their spring training and the Polish statesman and piano virtuoso Ignace Paderewski, who occasionally stayed at the hotel over a 25-year span beginning in 1914. The hotel and its elaborate bathhouse became the focal point of the hot-springs activity. Two years before the

grand hotel was completed, the city of El Paso de Robles was incorporated, and the name was commonly shortened to Paso Robles.

Paso Robles had the rural flavor of a cow town, and like most towns of its kind, it contained bordellos and experienced a few outlaw occurrences from rogues who tried to take advantage of goodwill. However, the visionaries, respectable townsfolk, ranchers, and farmers prevailed. Old-timers remember Paso Robles as a pleasant stop for travelers on Highway 101, El Camino Real, and how drivers tooted their horns and waved at friends on the street, causing some to call it "The Horn-Honkingest Town in the West." Until the early 1940s, Paso Robles had a population of 3,000. World War II and the building of Camp Roberts had a huge impact on the town, more than doubling its population. Gradually sections of land east of the Salinas River were annexed to the city, and by 1980, there were 9,045 residents. Eleven years later, the population had more than doubled to 21,000.

To show appreciation to ranchers and farmers, Pioneer Day was born in 1931, with merchants providing beverages—coffee for the adults and milk for the children—to accompany the families' picnic lunches in the park after a parade. The highlight of the first Pioneer Day parade was a 14-mule team pulling a wagon train. The wagons have been in every parade since. Pioneer Day was, and still is, a significant celebration in the hearts of local citizens.

Although there have been changes through the years, the heritage of the community is still remembered. In December, the Victorian houses on Vine Street are dressed up in the finest Christmas decorations. The fair—a success from its beginning in 1946 and where young people still proudly bring their animals to be judged—has developed into a large attraction that draws tens of thousands of people each year.

The buildings surrounding the park were revitalized in the early 1990s after the Downtown Paso Robles Main Street Association was formed. Its aim was to resurrect and protect the area; as a result, there are no malls in the center of town. There is an attractive continuity of style and a pleasant ambience around the park. When the 2003 San Simeon earthquake hit, some structures were destroyed and others damaged. Owners subsequently built replacements and reinforced other buildings.

The local grape-growing industry is booming and many vineyards have replaced dry-land farms. Numerous tasting rooms have sprung up and offer entertainment and food. Agricultural tourism is increasing as well. Tourists can visit olive orchards, vineyards, family farms, and ranches. Also available are options for guided hunting, trail rides, cattle drives, or photo opportunities for bald eagles and other wildlife.

Paso Robles, originally known as Hot Springs, has a history closely tied to the hot mineral springs and the people who came from far and wide to enjoy them. After many years of being ignored, the hot springs are gaining recognition again. The Paso Robles Inn, on the site of the former Hotel El Paso de Robles, has drilled its own geothermal well and has added hot mineral baths to some of the guest rooms. A spa in Paso Robles also offers indoor and outdoor enjoyment of the healing waters.

This book shows vintage photographs (beginning in the late 1880s) of Paso Robles and highlights some of the important aspects of culture and changes that made the town what it is today. Because of the nature of the format, this is not a comprehensive history.

One

THE HEALING PROPERTIES
SUNSHINE, SULFUR WATER, AND MUD

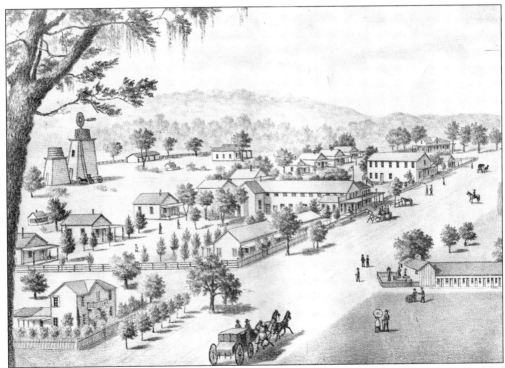

Traveling north by stagecoach through Paso Robles, visitors could see the residence of one of the town's founders, Drury W. James (lower left), a primitive bathhouse (lower right), the original Hotel El Paso de Robles (center), a few modest cottages, a store run by P. H. Dunn, two stagecoach barns, a blacksmith shop, and a schoolhouse. Continuing north, visitors saw oak-covered foothills to the west. To the east were mud springs and the Salinas River fringed with willows and cottonwood trees. (Courtesy Myron Angel's *History of San Luis Obispo County*, 1883.)

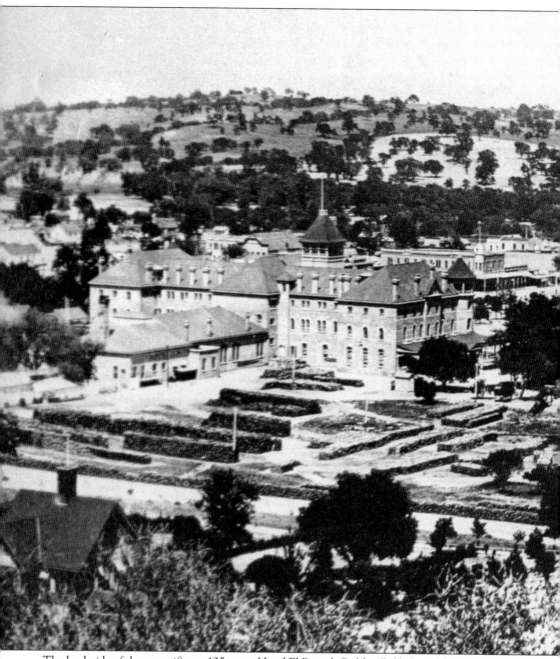

The back side of the magnificent 125-room Hotel El Paso de Robles (left), famed for its architectural beauty and spacious accommodations, dominates this photograph taken from a hill on the west side. The front of the structure faces Spring Street, the main thoroughfare through Paso Robles. A large combination dining room and ballroom wing extends out from the center section. Designed by architect Jacob Lenzer and completed in 1891, this three-story brick building encompassing the hot springs replaced the original small, wood-frame hotel erected in 1864. The neatly stacked

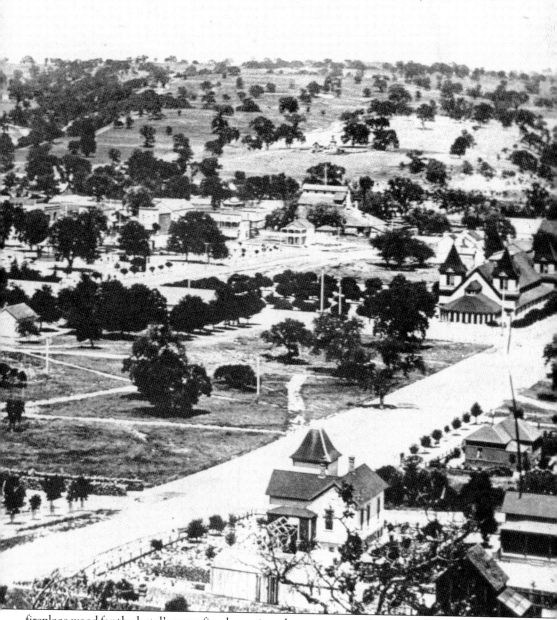

fireplace wood for the hotel's many fireplaces gives the appearance of manicured hedges. Although the official name was Hotel El Paso de Robles, the famous hotel was often referred to variously as the Paso Robles Hotel, El Paso de Robles Hotel, Hot Springs Hotel, El Paso de Robles Springs Hotel, or Paso Robles Hot Springs. On the northeast corner of Tenth and Spring Streets is the main bathhouse (upper right) with its four impressive towers. Built in 1888, it enclosed the original sulfur spring.

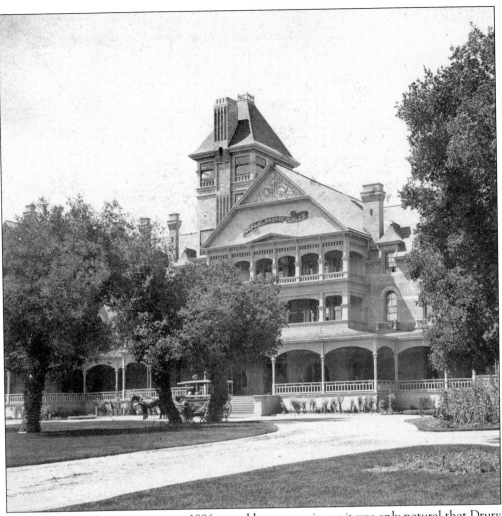

After the railroad came to town in 1886, travel became easier, so it was only natural that Drury James's dream of building a new hotel edifice became a reality. The Hotel El Paso de Robles, completed in 1891, accommodated the "jet-set" guests of 100 years ago. The stylish hotel, with its plush lobby, reading rooms, parlors, salons, and 300-seat dining room/ballroom, was touted as being equal to any of San Francisco's finest. Adjoining the hotel to the north was a clubhouse, which could be reached by means of a covered walkway. The clubhouse had a billiard and pool room and a large bowling alley. The hotel's 16-foot-wide verandas provided places to chat and watch games on the tennis courts, the croquet lawn, and bowling greens. The horse-drawn taxi at the hotel's front door took passengers to and from the mud baths at the north end of town and the train station a few blocks to the east. (Courtesy Smith/Wimmer Collection.)

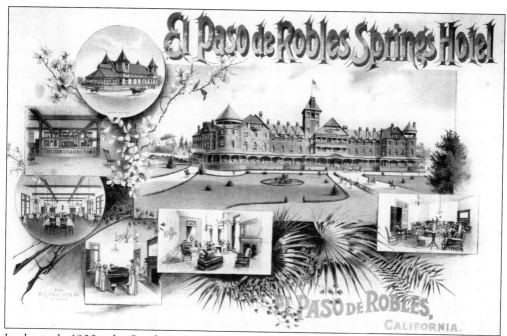

In the early 1900s, the Southern Pacific Railroad called their route from Los Angeles to San Francisco the "road of a thousand wonders." One of the highlights in the heart of Paso Robles was the magnificent showpiece: the Hotel El Paso de Robles. One of the ways by which the hotel was advertised was this *c.* 1892 poster that portrayed many of the amenities of the hotel. (Courtesy California State Library.)

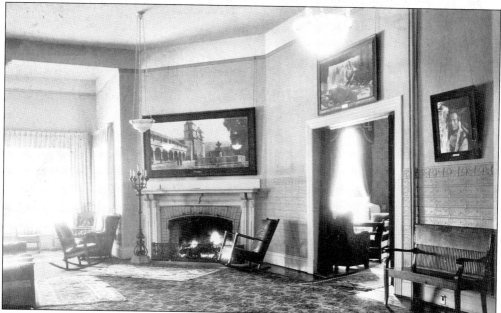

The spacious and well-lighted hotel suites were designed for comfort and enjoyment. The rooms had inviting fireplaces, hot and cold running water, radiators, and electric lights from the hotel's own generator. Once guests arrived at the hotel, all their requests were met. In this room, the mantel picture shows Mission Santa Barbara. (Courtesy Norma Moye.)

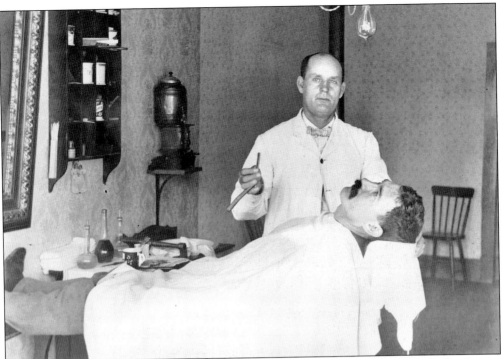

All types of amenities were available at the hotel, including the convenience of a barbershop to ensure that each gentleman was properly groomed. Dr. S. J. Call reclines in a dental chair while the barber gives him a shave in 1900.

Hotel guest Madame Helena Paderewska traveled by train with her small dog, Ping, concealing him in a specially constructed suitcase. The hotel provided a kennel for guests' pampered pups. (Courtesy Paderewski collection.)

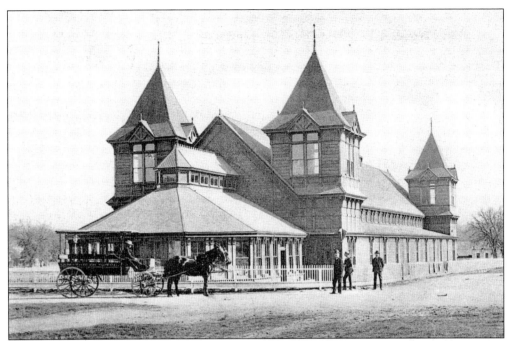

For its guests, the hotel built an elegant bathhouse in 1888 at the northeast corner of Tenth and Spring Streets. Replacing the original 1864 wooden building, this state-of-the-art $25,000 structure housed a large sulfur plunge. Baths were divided into ladies' and gentlemen's sections, where bathers could regulate their own water temperature. The 225-foot-long building burned down in 1913. The 2003 earthquake brought back an enormous gusher of sulfur water through the parking lot where this bathhouse once stood.

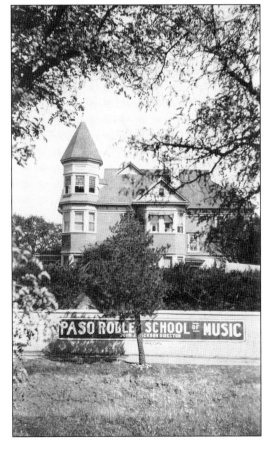

This three-story Victorian home, built in 1888 near Ninth and Spring Streets, belonged to one of the city's wealthy founders, Daniel Blackburn, and his wife, Cecelia. Dr. Karl Glass purchased the house and used it for a convalescent hospital and sanitarium. Later, under the direction of John J. Jackson, it served as the Paso Robles School of Music. The home of R. C. Heaton and his family for a time, the structure was destroyed by fire in February 1923. (Courtesy Dot Lefebvre, 1890 House.)

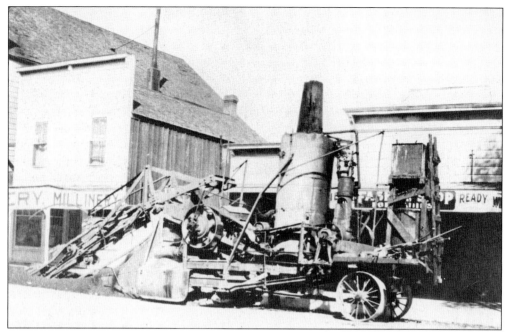

In the early 1900s, on the east side of Park Street between Twelfth and Thirteenth Streets, a steam-powered ditchdigger dug a trench in the unpaved street. This ditchdigger was a step up from the earlier days of manual digging or horse-drawn trenchers. The millinery store (left), with its typical Western false front, was located next to an opera house on the corner. (Courtesy Smith/Wimmer.)

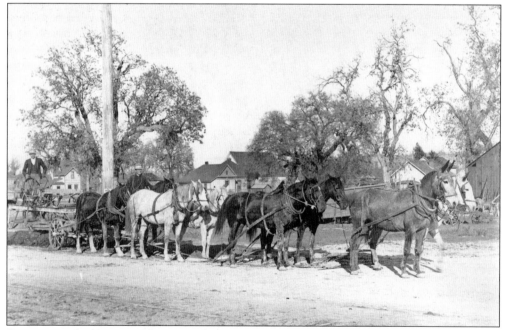

Streetcar tracks (foreground) were in the center of the street, and horses and wagons traveled in the dirt on each side, causing deep ruts to develop. Operating a grader, a worker smooths the dirt surface in 1900. This team is composed of a pair of lead mules followed by horses.

Shandon well drillers Dean Brown and Fred Tucker stand to the left of an artesian well around 1908. In the 1920s, it was reported that along Cholame Creek there was an artesian belt about a mile and a half wide. Near Shandon, more than 12 artesian wells with depths between 200 and 375 feet furnished water for growing alfalfa.

The Alexander Hotel, built in 1888 by Alexander Stowell, was on the northwest corner of Twelfth and Pine Streets. The hotel rooms occupied the second floor, while the ground floor housed an array of businesses until 1915, when the Paso Robles Mercantile was established. The lobby of the hotel shows Johnny Weathers checking in a guest . . . or is that his double? It is curious that the guest's right arm is translucent.

17

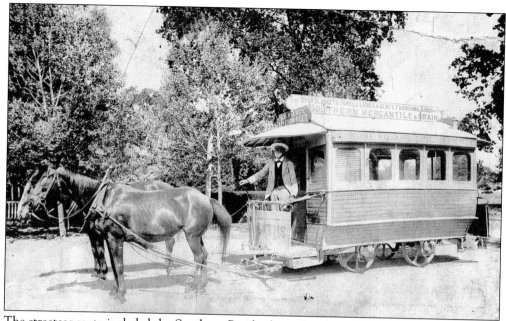

The streetcar route included the Southern Pacific depot, hotel, and the mud baths located two miles north of the hotel. The streetcar was first owned by Thaddeus Sherman and then jointly owned by Sherman and Hi Taylor; however, the partners had irreconcilable ideas regarding track maintenance. During the night of September 1, 1909, Taylor had some men remove one rail for a distance of five blocks—thus ending the 18-year-old streetcar line.

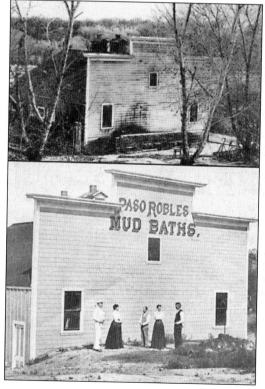

Rather than being preserved as nature presented them, the mud baths two miles north of the hotel were enclosed by the first building (above), which was constructed in 1865 and remodeled in 1902 (below). By the late 1800s and early 1900s, the mud baths were employed in a more systematic and "updated" approach to healing. The actual mud bath was overseen by a physician who directed patients to the appropriate treatment rooms. This structure was demolished in 1913 to make way for a new mud-bath building.

In 1914, a $25,000 contract was let to build a new mud-bath structure to replace the older one. This advertisement touted the many health benefits of the spa waters, which ranged from 116 to 140 degrees Fahrenheit. Clients were offered various treatments to help fight diverse diseases. The bathhouse was open to the public off and on until the late 1970s or early 1980s. The privately owned structure still stands. (Courtesy Dot Lefebvre, 1890 House.)

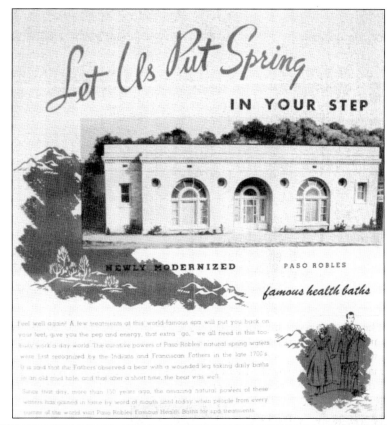

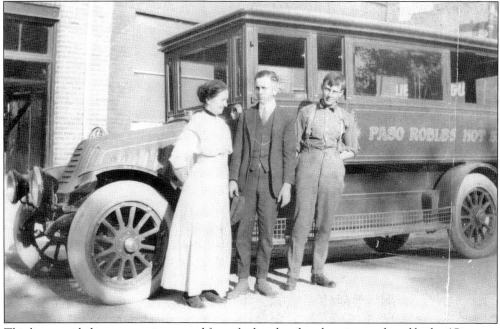

This bus provided transportation to and from the hotel, railroad station, and mud baths. (Courtesy Dorothea Proud.)

Before pioneers used the Santa Ysabel hot springs, Salinan Indians prized lake waters for their curative powers. That lake, created from a dam, was about a mile and a half east of the Salinas River. For the health seekers of the late 1800s, a bathhouse was erected and a new dam built to maintain the lake. Developers planned a settlement, but construction of the railroad on the river's opposite side dashed that plan. (Courtesy Bonnie Nelson.)

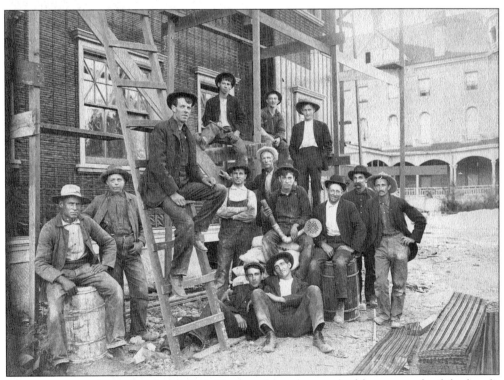

Construction workers take a break from their work on the new bathhouse, south of the hotel's main building, about 1905. One man (center) is holding a drainpipe, and sheets of building materials are on the ground (lower right).

20

This hot-sulfur bathhouse and plunge (*Kurhaus*) opened in January 1906. Physically connected to the hotel, it was constructed over the main hot spring, which had a daily flow exceeding two million gallons. This upscale facility offered more services and aesthetics than those of the 1888 bathhouse and was unequalled in this country. Its marble, mosaic, special glass, and polished white-cedar entrance greeted hotel guests. (Courtesy Dot Lefebvre, 1890 House.)

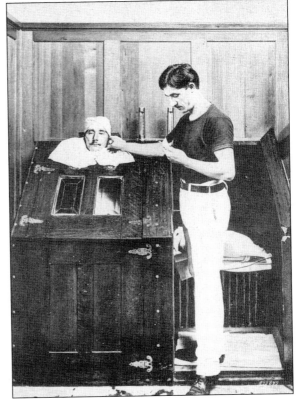

The hotel's sulfur baths embodied healing ideas from Europe and the Far East. The "cabinet treatment" in the men's bath was a sauna technique that piped hot air into the enclosure. The reverse side of this postcard, sent to San Francisco in 1910, read, "Dear Annie, this picture on the other side is my first start, I am doing well. Hope all is well at home." (Courtesy Dot Lefebvre, 1890 House.)

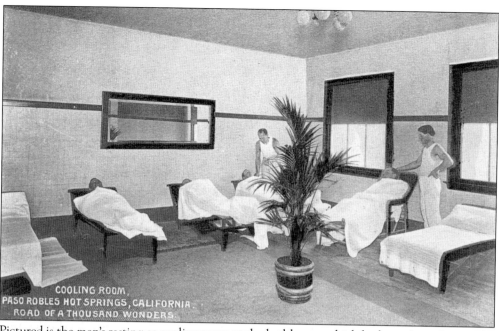

COOLING ROOM,
PASO ROBLES HOT SPRINGS, CALIFORNIA.
ROAD OF A THOUSAND WONDERS.

Pictured is the men's resting or cooling room at the bathhouse, which had a variety of rooms for assorted purposes to serve hotel guests. The bathhouse offered men's and women's dressing rooms, bath rooms, warm rooms, steam rooms, and more. Each area maintained its own temperature, and medical supervision was provided for the guests. (Courtesy Bonnie Nelson.)

Municipal Bath House, being erected at a cost of $25,000 by the city of Paso Robles to popularize the famous mineral waters of that place. The only one of its kind in the United States.

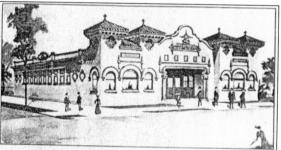

Paso Robles

Famous for its mineral waters and their miraculous cures.

Notable for its genial climate, rivaling any place in the world.

Remarkable for its cheap lands and its productive power

D e s t i n e d to be the most important trade center between San Francisco and Los Angeles. Paso Robles is the trade center of the northern end of San Luis Obispo County, and is backed up by a most prosperous and healthy farming community. The town site is acknowledged to be the most beautiful of any place on the Pacific Coast. To settlers and to residents it offers the best there is to be had in California. For further particulars address

SECRETARY BOARD OF TRADE

or any of the following reliable firms:

M. R. Van Wormer, Real Estate.
Paso Robles Bath House Co.
Geo. F. Bell, General Merchandise
Sperry Flour Co.
Bank of Paso Robles.

Paso Robles Light & Water Co.
A. Pfister, Banker.
R. C. Heaton, Furniture.
W. C. Bennett, Druggist.
Lundbeck & Hanson, Blacksmith.

Built in 1906 for $25,000, the Mission Revival style Municipal Bath House at 840 Eleventh Street offered rich and poor an opportunity to enjoy the waters' curative powers for 25¢ a day. This advertisement boasted that Paso Robles was "remarkable for its cheap lands . . . productive power . . . backed up by a most prosperous and healthy farming community." The bathhouse, in service for over 65 years, still stands but is now used for offices. (Courtesy Paso Robles Public Library.)

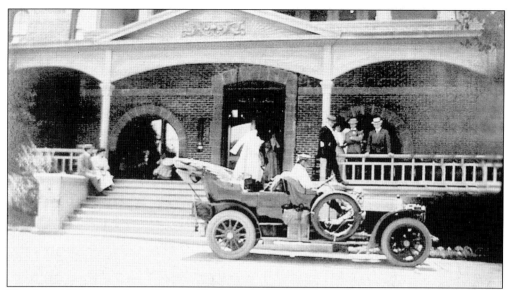

This June 1908 image shows Thomas Hopkins in a touring car in front of Hotel El Paso de Robles. Hopkins and Charlie Gardner (not shown) were hired by the H. C. Barroll family of Pasadena as mechanics and drivers for the family's trip to the East Coast. After leaving Paso Robles, they drove as far as Mount Washington, New Hampshire, and then shipped the car back to Pasadena. (Courtesy Lynn Peebles.)

This partial cover for the 1912 Thanksgiving dinner menu at Hotel El Paso de Robles shows Helen and Marshall Sawyer inspecting the turkeys. The dinner began with oyster cocktail, followed by delicate fish or "Filet Mignon Sauté Victor Hugo," a main course of turkey or goose with all the trimmings, gourmet salad, vegetables, champagne punch, and an array of rich desserts. The Santa Ysabel Dairy, located two miles away, supplied fresh milk, cream, and other dairy products. (Courtesy Paderewski Collection.)

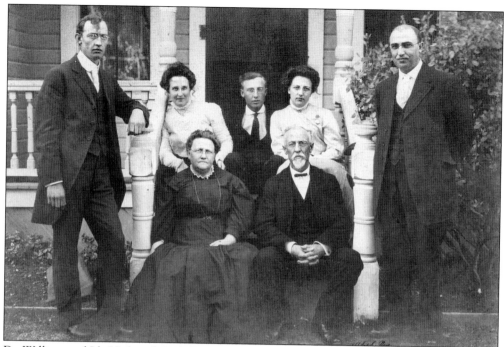

Dr. William and Ida Hedgpeth and their five children came to Paso Robles in 1906. Beside their home on Park Street, Hedgpeth eventually built a sanatorium, equipped with an operating room, nursery, and seven patient rooms. In 1916, his daughter Myrtle became the first female optometrist in California. Pictured around 1910, from left to right, are (first row) Ida and William Hedgpeth; (second row) Oscar, Pearl, Sam, Myrtle, and William.

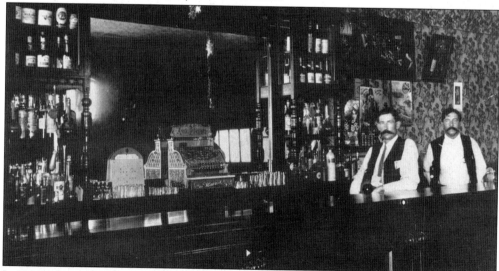

In 1908, Johnny Weathers and Joe Garcia were bartenders at Green Dragon Saloon, built in 1887 on Pine Street's west side between Twelfth and Thirteenth Streets. It was said that in exchange for fixing a knothole on the bar's top, a man got a double shot of whiskey. The bar is still in use on Pine Street at the Crooked Kilt. Townspeople could find many saloons until August 1912, when members of the Citizens' Ticket voted the People's Party out, and the town went dry. (Courtesy Donovan Schmitt and Troy Larkin.)

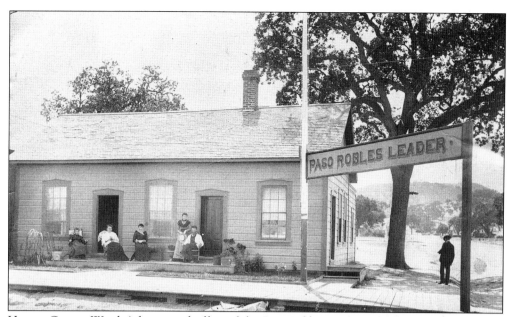

Horace George Wright's home and office of the *Paso Robles Leader*, the town's first newspaper, stood on the southwest corner of Thirteenth and Park Streets. The paper's first edition was printed in San Francisco and distributed to the prospective town-lot buyers who arrived on a special excursion train for the November 17, 1886, land auction. Wright championed the temperance cause and happily announced the voting results in 1912, when Paso Robles became a dry town. (Courtesy Smith/Wimmer.)

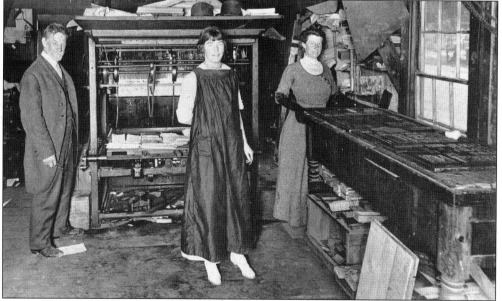

Horace G. Wright and his daughter Olive (right) are in the newspaper's pressroom. In the first issue in 1886, Wright stated, "The *Leader* comes to assist in increasing the population of San Luis Obispo County." Wright retired 33 and a half years later—goal accomplished. The size of Paso Robles surpassed his greatest expectations. Other newspapers had been established through the years; the *Leader* merged with one, the *Paso Robles Press*, in 1919. (Courtesy Smith/Wimmer.)

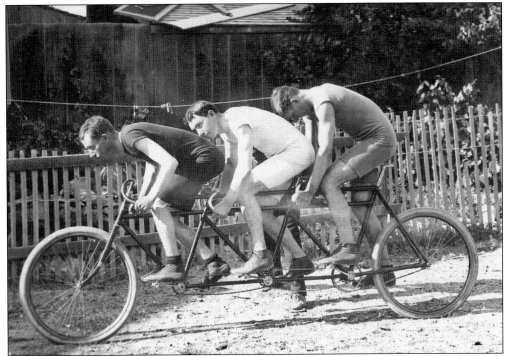

This 1898 photograph shows Clark Sherwood Smith, who became the son-in-law of Horace and Christie Wright in 1899, steering a unique bicycle built for three. Behind him are Jack Gruwell and Norman Cliff. Seven years earlier, Smith rode from Oakland to Paso Robles on a big-wheel bicycle, arriving after four days and weighing 30 pounds less. (Courtesy Smith/Wimmer.)

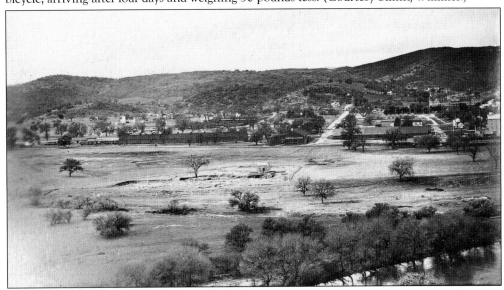

This winter photograph of Paso Robles in 1900 looks west across the Salinas River at Tenth Street. On both sides of the street, parallel to the railroad tracks, two long Southern Pacific Milling Company warehouses received and shipped hundreds of sacks of wheat from local farmers. The tall flour mill, on the far right, was in operation. The massive Hotel El Paso de Robles is also to the far right. (Courtesy Smith/Wimmer.)

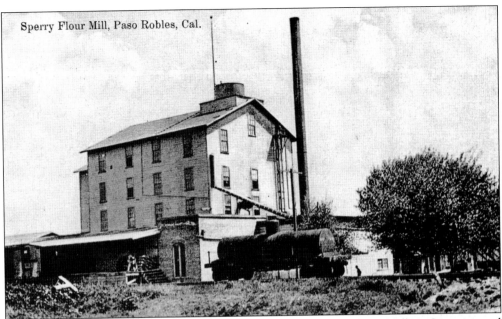

Sperry Flour Mill, Paso Robles, Cal.

The 1890-built flour mill on Riverside Avenue was sold in 1891 to Sperry Milling Company and used for flour production and storage. The mill's steam generator was the first electric power plant in Paso Robles. To accommodate changes in harvesting, from sacks to bulk grain, Ray Pelton partitioned the building into bins. A hopper scale weighed and distributed the grain throughout the building for later shipment. Operated by Eugene, the granary belonged to the Ernst brothers—Harold, Elsworth "Bud," Wilmar "Bim," and Eugene "Gene"—from 1949 to 1984. After extensive remodeling in 1992, the former granary now houses a restaurant, retail shops, and offices. (Courtesy Dorothy Lefebvre.)

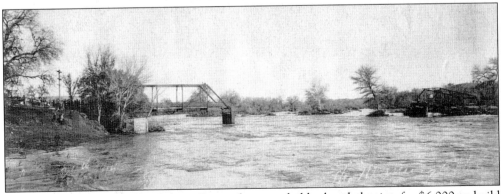

Needing a bridge across the Salinas River, the town held a bond election for $6,000 to build one. The bond failed. In the summer of 1887, the Blackburns and Drury James financed a bridge, later purchased by the county for $3,000, at Thirteenth Street. During the night of January 25, 1914, a huge rainstorm washed out the two center piers. Pictured is the bridge the next morning. Until it could be repaired, a swinging walkway between the two remaining spans enabled people to get to town.

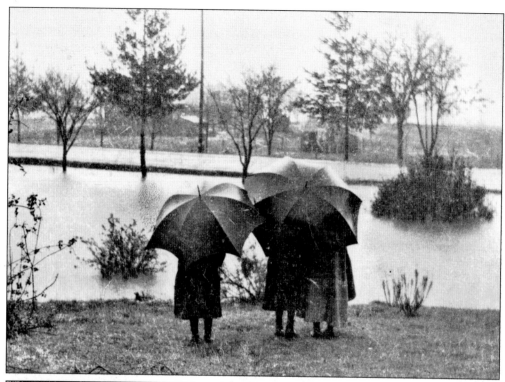

At Twenty-first and Spring Streets, Rosabel, Maude, and Meredith Smith watched 1914 floodwaters flowing from the Mountain Springs Road area to the Salinas River. (Courtesy Smith/Wimmer.)

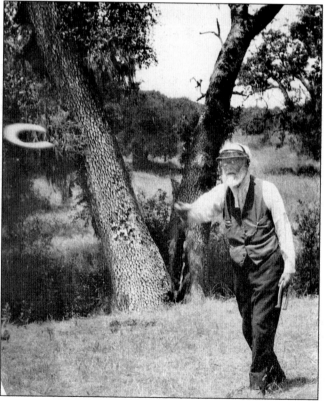

This *c.* 1920 image of horseshoe player and grandfather of the Smith sisters (above), Henry B. Smith, was captured by their photographer father, Clark S. Smith. Horseshoe competitions were promoted by the Smith family and became a regular part of early Pioneer Day activities. (Courtesy Smith/Wimmer.)

Two

THE TRAIN ARRIVES
BUILDING THE TOWN

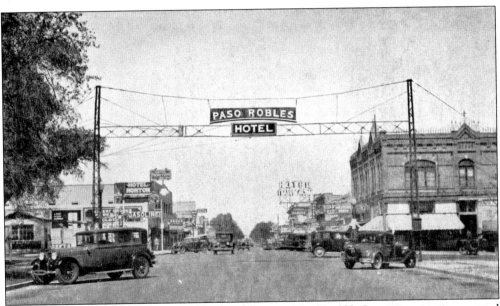

The large Paso Robles Hotel sign over Spring Street at the Twelfth Street intersection greeted visitors traveling north. The hotel's facilities originally included three contiguous blocks; Vine and Spring Streets were not connected by Twelfth Street as they are today. A Standard Oil Company service station was on the left, along with Hotel Norton. For many years, the two-story brick building on the right housed a hotel on the second floor, and Eagle Pharmacy operated from the Twelfth Street side on the ground level. The Canary Cottage, also on the ground level, was a popular restaurant for many years. At the next intersection of Thirteenth and Spring Streets, Pioneer Garage was on the southeast corner, and across the street to the north was the two-story Hotel Taylor.

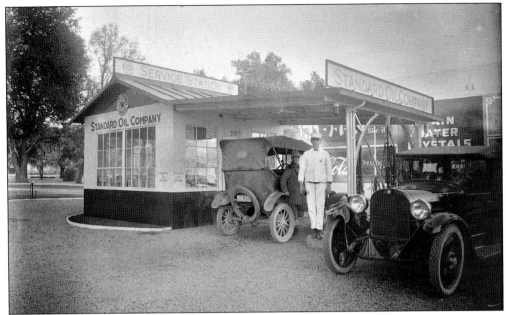

It appears that Oscar Henry Steaffens was waiting for a customer at the Standard Oil Company station at Twelfth and Spring Streets in the late 1920s. A few years later, Steaffens ran a Gilmore station at Seventh and Spring Streets. To keep his son out of trouble, Steaffens had him rake the gravel around the station. (Courtesy Smith/Wimmer.)

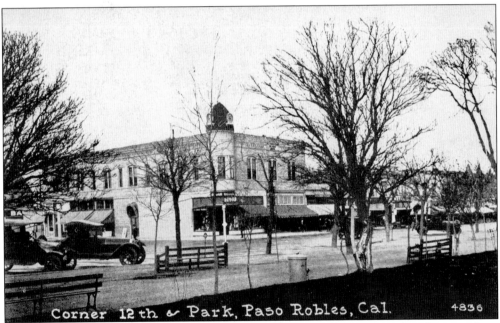

Corner 12th & Park, Paso Robles, Cal. 4836

This structure, built in 1892 at the corner of Twelfth and Park Streets, was directly across from the tree-lined city park. Designed by the wife of Daniel Blackburn, the distinctive clock tower, an icon for the town, was in the shape of an acorn cap to reflect the oak trees dotting the hillsides. It remained a Paso Robles feature until the building collapsed in the 2003 earthquake. (Courtesy Bonnie Nelson.)

This *c.* 1904 token, with a mirror on the back, was worth 10¢ at The Puck. Wanting more than 10¢, a thief gained entrance to Scoggan's saloon on Twelfth Street, robbing the cash register of all the money it contained—$10. The newspaper reported, "It wasn't the loss of money that worried John about 6:30 that morning but he was very indignant to think that an employee would run to his house and wake him out of dear, sweet, sound slumber just to tell him of such mere trivia as robbery." (Courtesy Dot Lefebvre, 1890 House.)

This 1890 Queen Anne–style house at 1803 Vine Street belonged first to G. W. Brewster, a foreman at the Hillman ranch, and then Joseph Dutra. The Moyes purchased the house; after extensive restoration work, it was listed in 1982 in the National Register of Historic Places. The former bank building at the corner of Thirteenth and Park Streets is the only other Paso Robles structure listed. (Courtesy Norma Moye.)

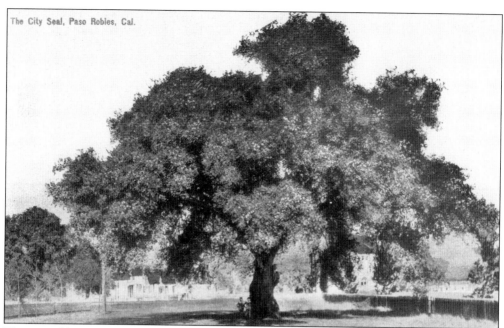

The City Seal, Paso Robles, Cal.

The coastal live oak (*Quercus agrifolia*) pictured on this 1912 postcard was used to symbolize Paso Robles on its city seal. (Courtesy Dot Lefebvre, 1890 House.)

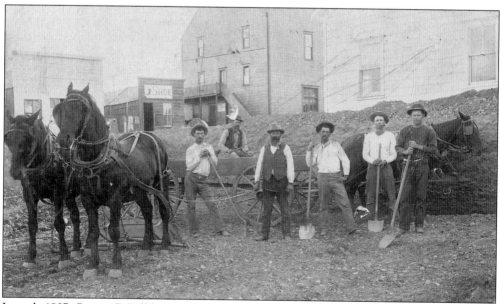

In early 1887, George F. Bell built a small room on Pine Street, stocked it with $5,000 worth of general merchandise, and began a thriving business. Soon the room was not large enough, so he constructed a new building on the northwest corner of Thirteenth and Pine Streets. Pictured from left to right are Ed Maze, ? Taylor, Bass Taylor, Harry Clark, Art Clark, and ? Bryant (the brother of Marguerite Maze's mother). (Courtesy Ellen Schroeder.)

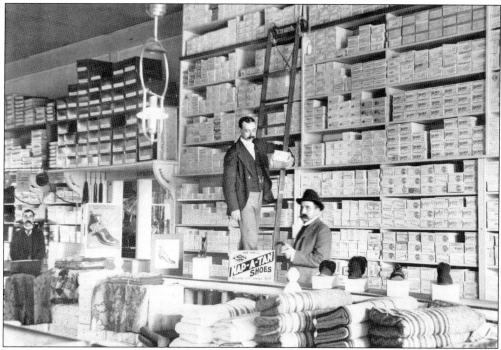

Jim Pierce climbs the ladder at Bell's Store to get a pair of shoes for a customer, while Tom Stevens looks on from the back around 1900. Bell's was a general store stocked with nearly everything: groceries, fabric, notions, electric power plants for farms, Studebaker wagons, and more. Bell's, where people gathered and exchanged news, served the needs of the community from 1886 until George Bell announced his retirement in 1927 at the age of 83.

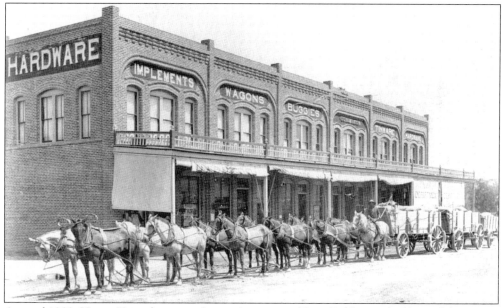

Around 1902, Henry Twisselmann, a farmer from east of Paso Robles, parked his jerk-line team and wagons loaded with sacks of grain before going to Bell's Store for supplies. Bell became known as having one of the best stores in the area. (Courtesy Doreen Roden.)

At the corner of Thirteenth and Park Streets, one worker is on the roof while other men are completing the finishing touches to the original building's addition on the right. Used as a bank for many years, the structure housed First National Bank, which later merged with Bank of Italy. (Courtesy Norma Moye.)

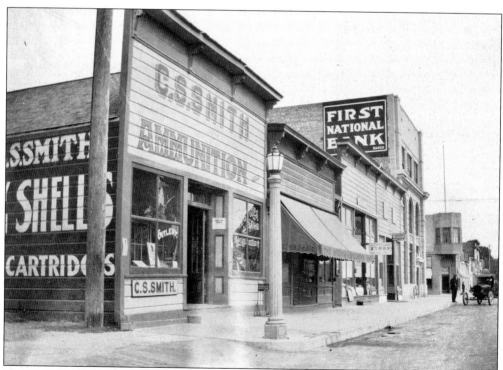

This C. S. Smith building at 1225 Park Street was moved to the back of the lot in 1922, and a two-story, flat-roofed brick building was constructed in its place. As the popularity of the area's superb hunting spread, Smith's business in guns and ammunition grew. (Courtesy Norma Moye.)

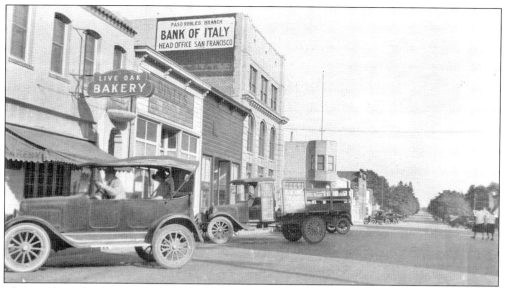

The people in the touring car may have stopped for a treat at Live Oak Bakery before doing their banking. On November 3, 1930, Bank of Italy, founded in 1904 in San Francisco, merged with Bank of America, under which name it was the only bank in Paso Robles for 21 years. (Courtesy Smith/Wimmer.)

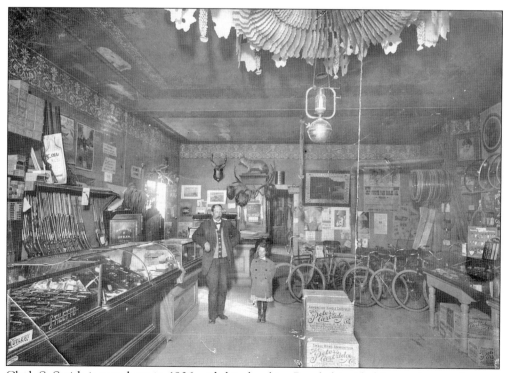

Clark S. Smith is seen here in 1906 with his daughter Rosabel inside his sporting-goods store. Smith began his sporting-goods business in 1893, and the establishment continued for nearly 100 years. (Courtesy Smith/Wimmer.)

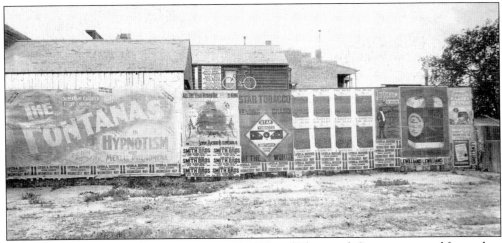

Sides of the buildings on Park Street between Twelfth and Thirteenth Streets were used for product and event advertisements. With their hypnotic marvels, the Fontanas entertained audiences at the opera house. To advertise their Park Street store, the Smith brothers displayed a bicycle above one of the billboards. Their store was a combination fix-it shop, gun store, watch-repair shop, and more. (Courtesy Smith/Wimmer.)

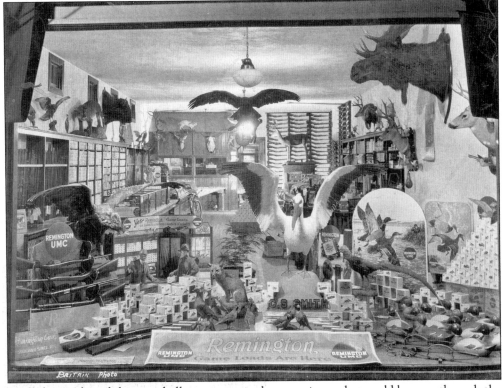

Stuffed animals and shotgun shells were among the many items that could be seen through the window of the new C. S. Smith Sporting Goods store in 1923. Mr. Spears, a taxidermist who rented the original store in the back and occasionally paid his rent with stuffed animals, mounted some of the animals; others were purchased from out of the area. Many of the mounted animals are on display at the Pioneer Museum. (Courtesy Smith/Wimmer.)

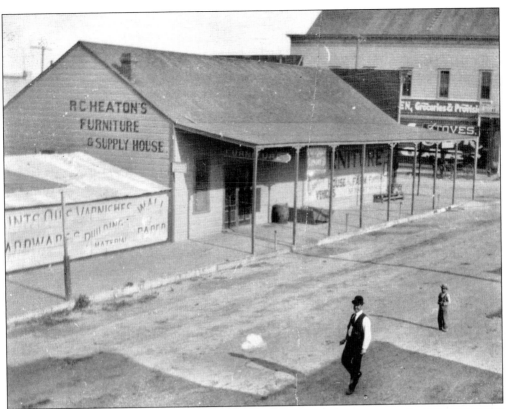

A Paso Roblan and a lad stroll north on Park Street in front of R. C. Heaton's Furniture and Supply House, which by 1927 was one of the largest furniture and hardware stores in the county. It was established in 1886 by Heaton and operated until 1983. A fire destroyed the building (above), and a new structure, which still stands, was built in 1936. Beyond Heaton's store, on the southeast corner, was the opera house where there were performances by traveling dramatic groups, plays directed by local citizens, and musical entertainment. (Courtesy Smith/Wimmer.)

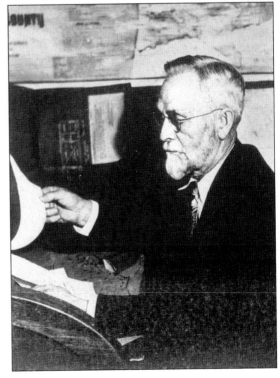

In the late 1920s, R. C. Heaton (right) turned his business over to family members, and he worked in banking and real estate. (Courtesy Jeanette Mayfield.)

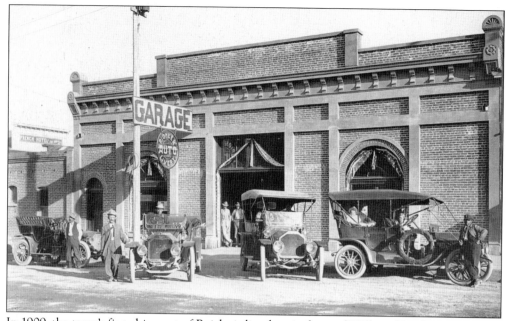

In 1909, the town's first shipment of Buicks is lined up in front of William Henderson's Pioneer Auto Livery on the southwest corner of Thirteenth and Pine Streets. Pictured from left to right are Ben Wieser, Billy Henderson, Elmer Bollinger, and two unidentified men in the doorway. Posed with the Buick on the right is the Twisselmann family: Henry and his mother, Eleanora "Nora," in the backseat; Eleanor, in the front seat; and Christian "Chris," standing. (Courtesy Doreen Roden.)

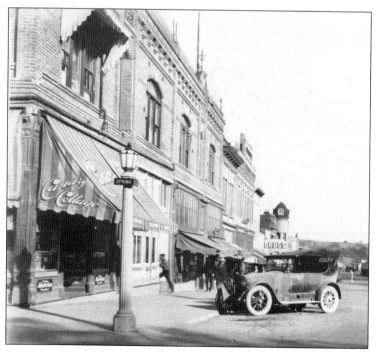

The Canary Cottage, a soda fountain and restaurant established in 1914, gained widespread fame and by 1941 employed from 8 to 14 people. After church on Sundays, Dr. Gifford Sobey often ate dinner (the midday meal) there. In the midst of dinner, he was frequently called out for a medical need because the telephone operator knew that she could usually reach him at the restaurant. (Courtesy Chimney Rock Ranch files.)

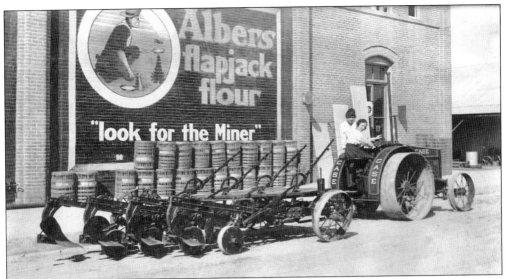

This brick wall advertised Albers Flapjack Flour in 1922 and served as a backdrop for the ladies demonstrating the new moldboard plow and tractor. Rolls of hog wire are stacked by the wall. (Courtesy Norma Moye.)

Churches, the cornerstone of community life, were gradually established. Several families formed a Methodist congregation in 1887 and constructed their first building at Eighth and Oak Streets in 1888 after 10 weeks of work. In 1891, they purchased a lot on the corner of Fourteenth and Oak Streets for $450 and moved the building to the new lot, where it was used until 1926. The edifice was replaced by the building pictured here, which was irreparably damaged by the 2003 earthquake.

Members of Paso Robles Christian Church, organized in 1888, laid this brick building's cornerstone at Fifteenth and Oak Streets in August of the same year. The building served the congregation until 1965, when it was demolished because repairs would have been too costly in comparison to new construction. A new sanctuary was built in nine months, using all volunteer labor except for one paid foreman. (Courtesy Live Oak Christian Church.)

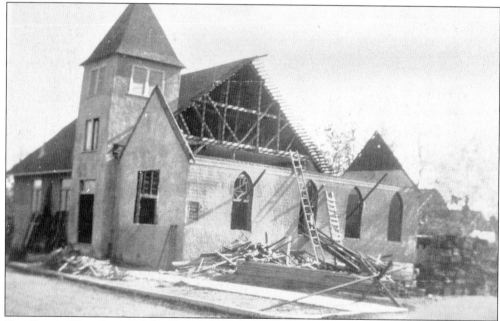

First Baptist Church, established by 12 men and women in 1888, purchased a lot for $50 in 1892 at Seventeenth and Park Streets—although some members felt that it was too far out of town. Within five weeks, they had made bricks and completed a one-story brick chapel; additions were made in 1914. In 1923, the roof was removed from the original chapel (above), and a second story and balcony were added. (Courtesy First Baptist Church.)

"What therefore God hath joined together, let not man put asunder," from Matthew 19:6, is printed at the top of this certificate for Michael Gerst and Nettie Botts, who were married in Paso Robles in 1882. Gerst, born in New York in 1850, left home at age 17 for Ohio, came to Paso Robles, and then started farming in the Estrella area east of the Salinas River. The certificate represents those who came, married, had children, and worked the land.

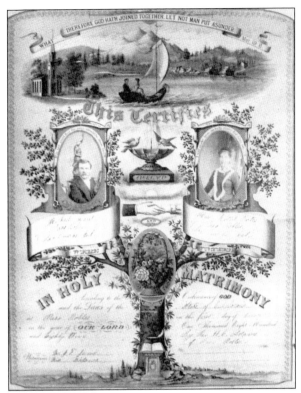

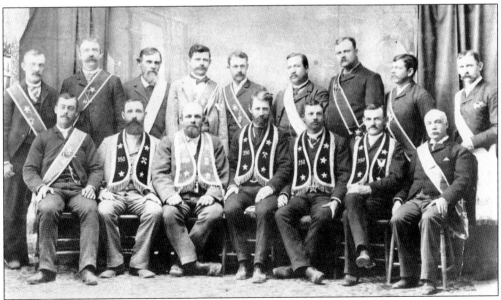

The Independent Order of Odd Fellows (IOOF), Santa Lucia 350, erected a meeting hall on Park Street between Twelfth and Thirteenth Streets in 1910–1911. Pictured from left to right, in 1890, are the following: (first row) DeWitt Van Eaten, Ed Abernathy, Ben Pierce, H. G. Wright, Henry Williams, S. B. Irwin, ? Tillinghast; (second row) ? Hobson, Joe Abernathy, Joe Tidrow, Henry Findley, Dr. Call, Frank Backestra, unidentified, Len Williams, ? Richards. As the town's population increased, nearly every fraternal organization was represented in subordinate lodges.

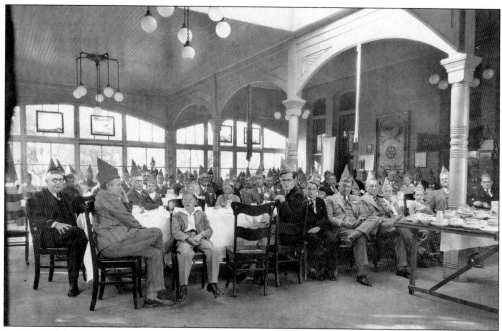

In December 1930, Paso Robles Rotary Club members and sons ate dinner and donned hats in the dining room of the Hotel El Paso de Robles. Longtime local medical doctor Gifford Sobey, in the gray suit, is sitting sideways in front. (Courtesy Smith/Wimmer.)

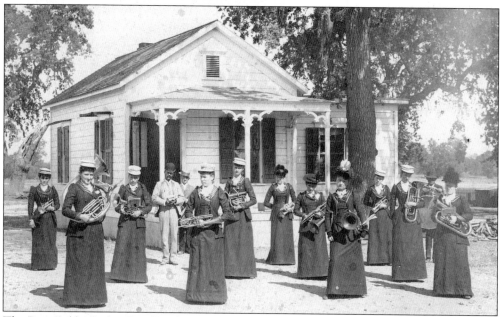

The Paso Robles Ladies Band performed 14 pieces at their first public concert held in the opera house on June 4, 1892. William G. Knight was the conductor, and some of the band members were Emma Barnett Knight, Bertie Belle Barnett Bray, and Lora Barnett Richards. (Courtesy Norma Moye.)

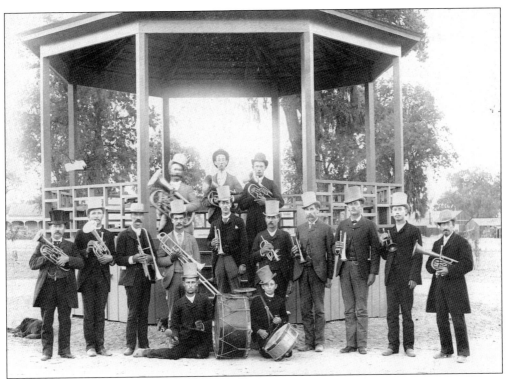

The men's band poses in front of the city park's gazebo, where they entertained their audiences during warm summer evenings. In 1912, an article in the local newspaper indicated that the Paso Robles Band would be changing its concerts from Sunday nights to Wednesday evenings to increase attendance because "heretofore the boys have been playing to the trees in the park." (Courtesy Ellen Schroeder.)

Francis Marion Shimmin is seen here with his baritone (or possibly a euphonium) horn, which he played in the local men's band in 1916. The father of Francis, Marion, immigrated to the United States from Ireland in 1850, came to Paso Robles in the late 1800s, and became a coproprietor of Shimmin and Stevens Emporium on Twelfth Street. Francis operated Shimmin and Nye Tire Shop on Spring Street, and he served on the Paso Robles Fire Department for more than 25 years. (Courtesy Dave Steaffens.)

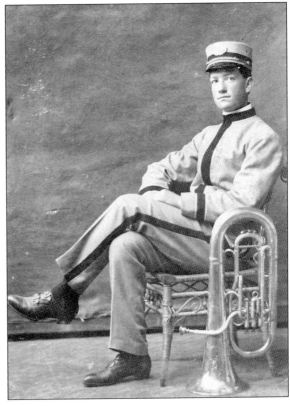

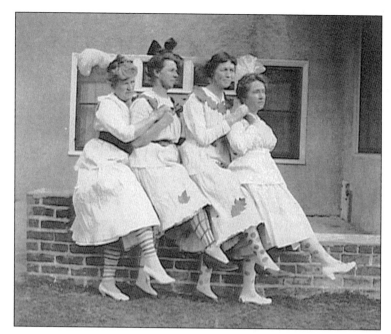

The women's quartet entertained at many community events from 1917 to 1919. Pictured from left to right are Lucile Lewis, Olive Smith, Ruth Trussler, and Lois Webster. Note their striped, plaid, and polka-dotted socks. (Courtesy Smith/Wimmer.)

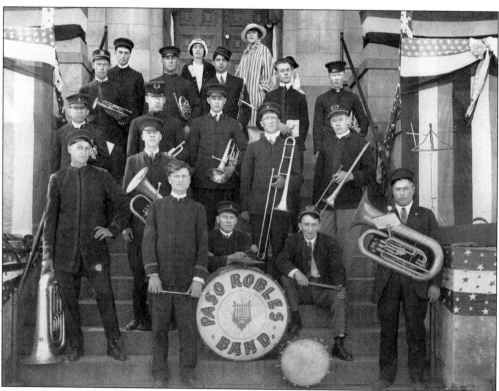

Under the direction of bandleader Will Ernst (with baton), the Paso Robles City Band enjoyed sharing their music. They are pictured here in 1923. Some of the band members included Walter Lovegren (center), Truman Brooks, Elmer Ernst, Kent Hibbard, Walter Lundbeck, Tuley Lundbeck, Francis Shimmin, and Dow Woods. (Courtesy Smith/Wimmer.)

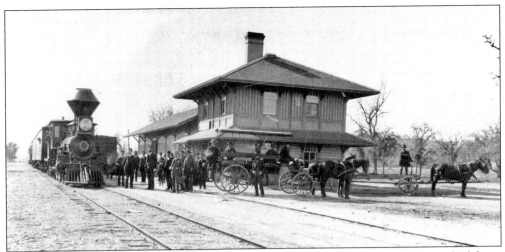

The train made its Paso Robles debut on October 31, 1886 after 1,100 Chinese laborers laid down tracks south from Soledad. The tracks from San Miguel to Paso Robles were completed in 13 days. Templeton was the end of the railroad line for seven and a half years, and travelers went by stagecoach over Cuesta Grade. The Paso Robles stationmaster lived on the second floor of the depot, which was completed in 1887. Train travel made it much easier for passengers from San Francisco to visit the hot springs and the grand hotel. The train had a major impact on the development of the new community. Seventeen days after the first train arrived, the grand auction of town lots was held. Sales in the first month amounted to $39,600, mostly from business lots with some lots selling for as low as $75. (Courtesy Norma Moye.)

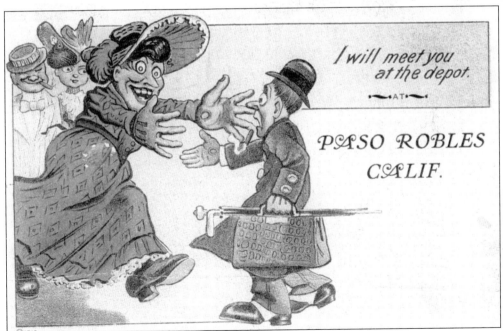

This postcard depicts an overzealous woman at the train depot startling a new arrival with her welcome. With golf club in hand, he may have been heading for the hotel's golf course across the Salinas River. (Courtesy Bonnie Nelson.)

Seeking relief for health problems, John Brown Testerman came to Paso Robles in 1885. After the town site was surveyed, he purchased the first lot at the November 1886 auction and built a house. He became a boot maker and shoe repairman, so it was natural to open his own shop in the front room of his 1140 Pine Street house. (Courtesy the Testerman family.)

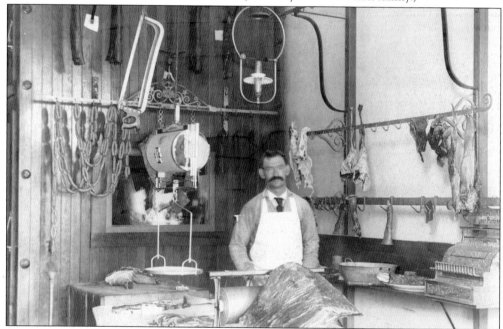

Shoppers could choose from an assortment of fresh meat—sausage, pigs' feet, or tongue—available at the Central Meat Market, located on Park Street near Twelfth Street. Behind the roll of paper, the butcher stands ready to assist in 1900. Until about 1911, the price of beef averaged about 5¢ per pound.

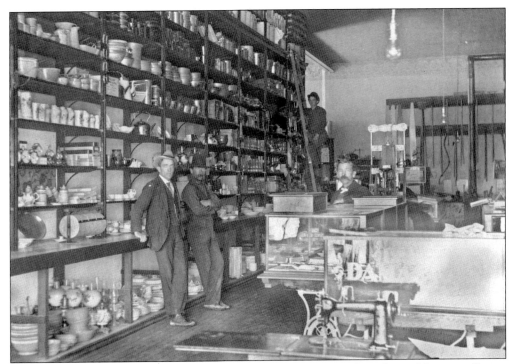

Pfister and Ladd Hardware Store, located on Twelfth Street across from the park between Spring and Park Streets, stocked many items used around the home or farm. A few of the items pictured are dishes, a teakettle, clocks, lamps, and kerosene-lamp chimneys. The store also sold shoes, buckets, baskets, crocks, hay forks, and more. Pictured from left to right are Frank Ladd (part owner), unidentified, Ed Brenlin (on ladder), and Tom Henry (seated).

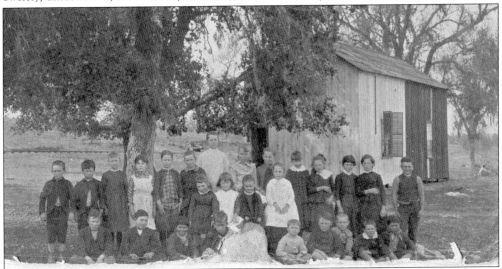

In 1877, Drury W. James, one of the founders of Paso Robles, built the first schoolhouse in Paso Robles, a 14-by-18-foot building on Riverside Avenue between Twelfth and Thirteenth Streets. Enrollment was stable until 1886, when more families arrived and the schoolhouse became too small to accommodate the children. One end wall was removed and the building enlarged to twice its original size. (Courtesy Smith/Wimmer.)

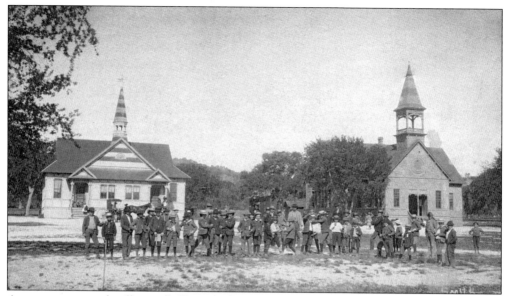

A new two-room schoolhouse (left) was built at the corner of Seventeenth and Oak Streets after the first school-tax election in 1887. Two years later, another schoolhouse (right) was built. Both structures were moved across the street and replaced in 1892 with a three-story, brick building, the county's first high school. After the 1906 San Francisco earthquake, cracks developed in the third level, and it was removed in 1924. (Courtesy Smith/Wimmer.)

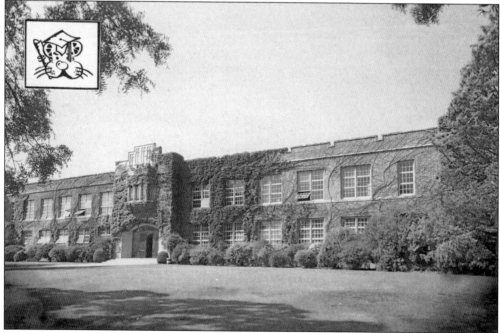

From 1924 to 1981, the high school Bearcats attended classes in this ivy (Virginia creeper)-covered building on Spring Street until the current high school was built on Niblick Road. The former high school then became George H. Flamson Middle School. Declared unsafe in 1958, the building was extensively remodeled after passage of a $365,000 bond. Damaged in the 2003 earthquake, the structure was demolished in 2005. (Courtesy Darrell Radford.)

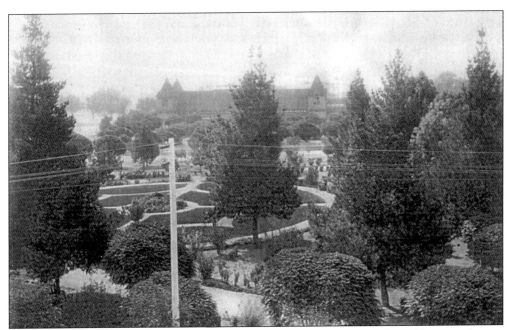

With the stipulation that the grounds be used only for the pleasure of the public—not for any commercial activities—the benefactors of the town donated two full blocks for a park directly across the street from the grand-hotel site. The park was landscaped in 1887, and shade trees were planted through the years during Arbor Day ceremonies. The 1888 bathhouse can be seen in the distance. (Courtesy Smith/Wimmer.)

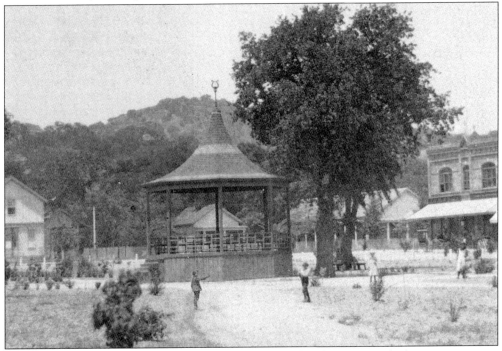

The gazebo, built in 1890, provided a bandstand for weekly band concerts and other entertainment. (Courtesy Ellen Schroeder.)

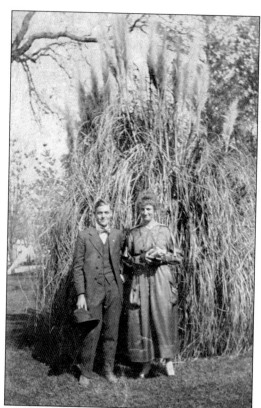

Enjoying an afternoon in the large, tree-filled park are friends Bob Fleig and Emma Klintworth, who pose here in front of a clump of pampas grass in 1918. A mission bell was placed in the park in 1912, when bells were placed along the mission trail on El Camino Real. A carousel and other playground equipment provided enjoyment for many children over the years. The oldest park in the county, it was the pride of the community. (Courtesy Violet Ernst.)

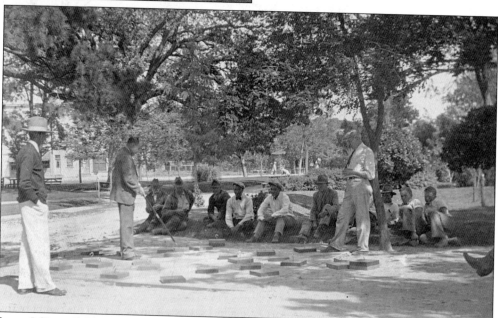

James J. Davis (left) watched one of the 1932 checker games that took place regularly on the south side of the park, where horseshoe pits are now located. A stick with a wire on the end was used by the men to pick up the large metal checkers. At one time, painted brake drums were used as checkers. (Courtesy Ann Davis Martinez.)

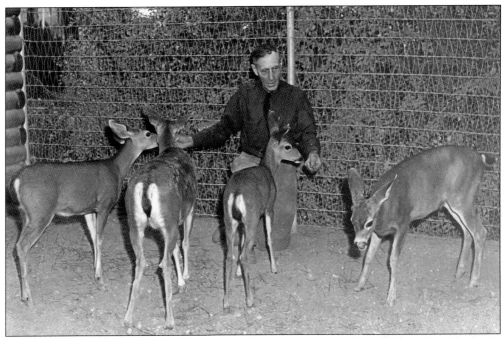

Deer that resided in the park are being fed by Alfred A. Rowe around 1940. A log building to the left protected the deer from the weather. The herd began in 1937 with the donation of Wimpy, who bore 18 fawns during her 15-year life. (Courtesy Don Campbell.)

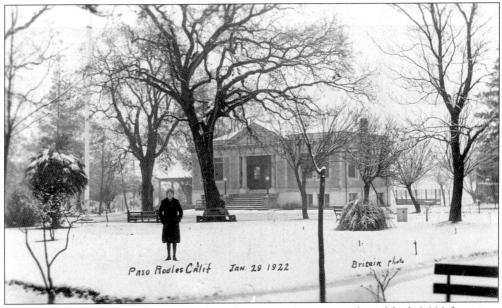

Paso Robles and San Luis Obispo were the only cities in the county selected for $10,000 donations from oil tycoon Andrew Carnegie to construct public libraries. This library, in the center of the park, was dedicated in 1908. A rare event occurred on January 19, 1922, when snow fell on the building. After a new library edifice was constructed in 1995, the Carnegie Building housed the Paso Robles Historical Society until the 2003 earthquake damaged the structure, temporarily relocating the society. (Courtesy Bonnie Nelson.)

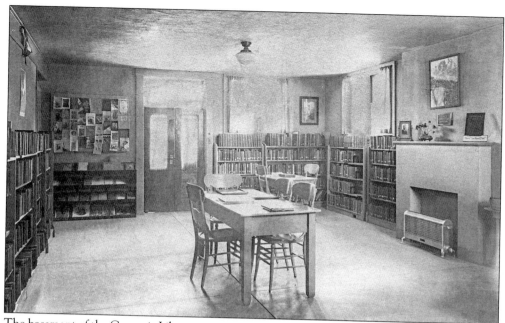

The basement of the Carnegie Library was renovated, and in 1912, the juvenile section was moved from the main room to the west half of the basement. In 1938, it was moved to the east half and steps were installed. (Courtesy Paso Robles Historical Society.)

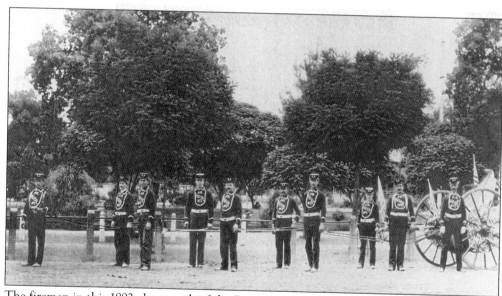

The firemen in this 1892 photograph of the Paso Robles Hose Company No. 1 are, from left to right, ? Triplet, Ernest Anderson, Albert Bryant, Fred Maze, Frank Lundbeck, ? Vassar, Ed Maze, Percy Bilton, Dave Elliot, and J. B. Ward. The city fathers recognized the necessity of a fire department, and the first fire department was organized in 1890. Volunteers faithfully served Paso Robles until 2004, when they were phased out and replaced with full-time, salaried firefighters. (Courtesy Katie Anderson.)

In February 1890, a local blacksmith made a triangle to alert the firemen of a fire. It was replaced a year later with this large bell, which was used until a siren was installed during the 1920s in the Pioneer Garage across the street from the firehouse. The bell was acquired by Clark S. Smith and moved to his Spring Street home, where children played on it. Clark's son, Clark M., is standing on the board, which spun around like a merry-go-round. This bell is now on exhibit at the Pioneer Museum.

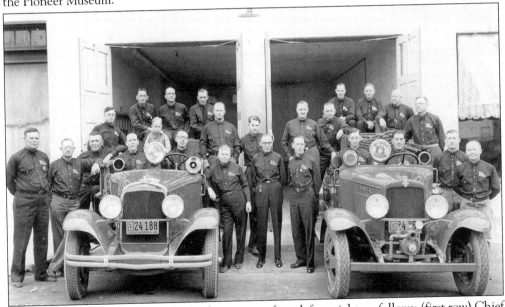

In this October 1936 photograph, the firemen are, from left to right, as follows: (first row) Chief L. Maynard French, unidentified, Herbert "Bull" Mastagni, Bill Lundbeck, Billy Lundbeck, Bert Riggs, Dr. Gifford Sobey, H. H. Smith, Bert Noyes, unidentified, Lavern Payne, Price Haynes, Bert Davis; (second row) Gene Booth, Herman Bliss, Francis Shimmin, Les Hardy, Frank Marston, Jerry Brush, Eric Schwandt, Elmer Bollinger, ? Unger, Don Orcutt Sr., Bob Nelson, Fred Maze. Purchased in 1931, both fire trucks were equipped with electric sirens and 50-candlepower searchlights. Members of Paso Robles High School Class of 1969 restored the Chevrolet (right) and have driven it in the Pioneer Day parade.

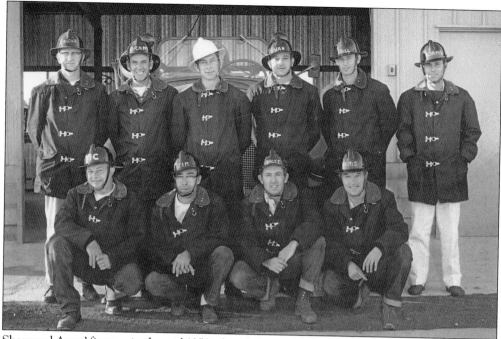

Sherwood Acres' firemen in the mid-1950s, from left to right, are as follows: (first row) Vic Buckley, Jim Jenkins, Bruce Tuley, Hillis Schinbine; (second row) Robert Rader, Oram O'Neal, Don Mastagni (captain), Kenneth Van Blargen, Billie C. White, Bob Adams. Maynard French, fire chief, and Herbert Mastagni, captain, worked out of the main station on Thirteenth Street. By 1987, there were 50 volunteer firefighters assigned to three strategic locations: main station, airport, and Sherwood Acres. The fire chief and fire-prevention officer were full-time personnel.

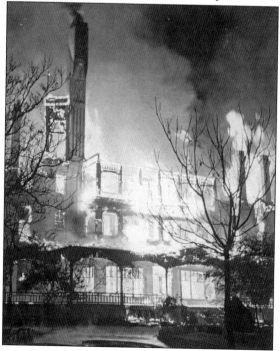

With the aid of fire departments from neighboring communities, firemen valiantly fought the fire at Hotel El Paso de Robles on the night of December 12, 1940. When they realized that they would be unable to save the central part of the structure, they concentrated on saving the dining room wing and the bathhouse. Even though the night was cold, spectators watching from the park across the street had to keep backing up because of the fire's heat.

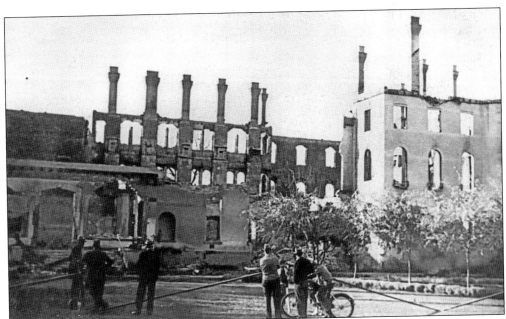

Chimneys, bricks, and memories were all that remained following the devastating hotel fire. After running to all 125 rooms to notify each occupant of the fire, J. H. Emsley, the night clerk, died of an apparent heart attack. The hotel's heyday lasted into the 1920s, but it then fell on hard times as did the rest of the country. There had been several owners, and the latest one was in the process of refurbishing the rooms just before the fire. (Courtesy Bonnie Nelson.)

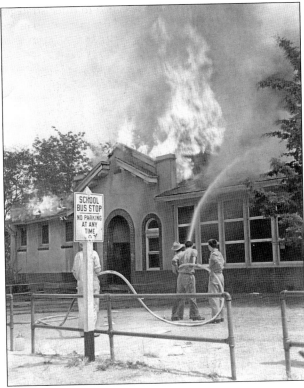

In July 1953, firemen worked to extinguish the fire that engulfed the Paso Robles Grammar School Building on Vine Street between Seventeenth and Eighteenth Streets but were unable to save it. Many of the children started school in September in temporary locations at the fairgrounds and at nearby churches while the school was being rebuilt. This building was constructed with a $40,000 bond that passed in 1916.

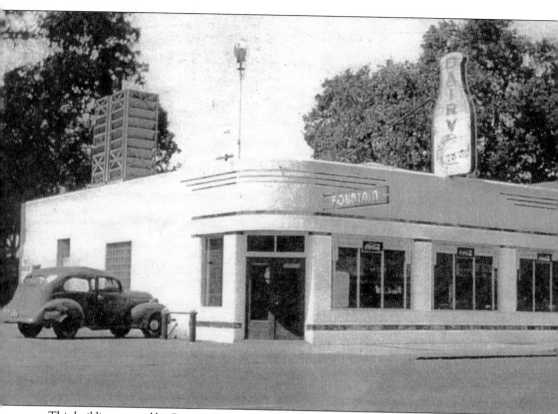

This building, owned by Gregory Ross, at 1421 Spring Street had a dual purpose: milk from Crescent Dairy, operated by Rossi's brother Vincent and located south of Templeton, was pasteurized and bottled in the back, and sodas and ice-cream were served in the front. In 1940, brothers-in-law Dwight A. Martin and Vernon L. Sturgeon assumed the delivery service of Crescent Dairy and installed the very latest in equipment to meet the demand created by the rapid growth of Paso Robles and northern San Luis Obispo County. An article about the dairy in the 1941 *Paso Robles Press* publication, *Camp Roberts Souvenir Edition,* stated, "The latest and most sanitary bottle washer in our plant thoroughly washes and sterilizes bottles at the rate of 318 each 10 minutes. These are but a few of the reasons why the Crescent Dairy today will deliver more than 800 gallons of milk; 525 gallons in bottles . . . with a bulk business of approximately 235 gallons." Each morning before going to school, Martin's son Dwight Jr. or "Pepper," helped bottle the milk, and then he and his brother Gladwyn delivered it. Wire baskets on racks in a walk-in freezer room were rented to area residents for frozen vegetables, fruit, and home-butchered meat. Numbers on the baskets enabled customers to identify their frozen food, and they were trusted to take food only from their own baskets.

Three

THE
INDUSTRIOUS FARMERS
GRAIN, ANIMALS, AND ALMONDS

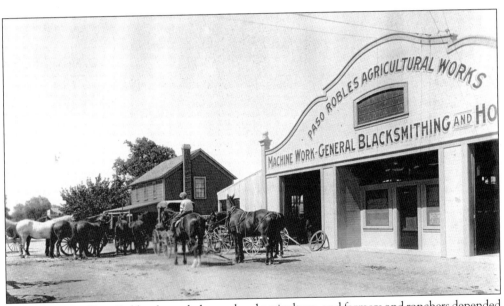

The economy of Paso Robles depended upon local agriculture, and farmers and ranchers depended upon local businesses. One of the many local establishments that provided services for the area farmers was the Paso Robles Agricultural Works at the corner of Twelfth and Railroad Streets. The business was formed by twin brothers, Frank and Peter Lundbeck, who emigrated from Sweden. After Peter's early death, Frank had other partners. The last associate was his son-in-law, Charles W. Anderson, who also owned a service garage and Studebaker dealership across the street. Anderson's brother-in-law Bill Lundbeck, a well-known horseshoer and blacksmith, worked at the Agricultural Works from 1910 until the business closed in 1963. The blacksmiths shod horses, sharpened plows and disks, made cattle brands, repaired farm implements, and during later years, constructed cattle squeezes, horse trailers, and truck beds. After the business closed, the building was torn down to make way for a city parking lot. When the Pioneer Museum's second building was constructed in 1980, the facade was designed to resemble the Agricultural Works. (Courtesy Katie Anderson.)

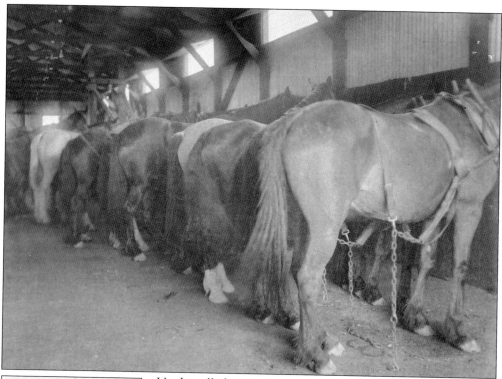

Used in all phases of farming, horses were brought to the blacksmith shop and fitted with shoes. After delivering a load of grain, a farmer often brought in his team of 14 to 18 horses to be shod before returning home. The shoeing area was large enough to accommodate several horses at one time while the rest waited outside. Hooves, which constantly grew, like toenails, had to be filed down, and then shoes were selected and molded to fit the horse's foot as is done today. (Courtesy Katie Anderson.)

While the Lundbeck family served the community's blacksmithing needs on one corner, Frederic "Fred" Cuendet did the same a block away at Thirteenth and Railroad Streets. Cuendet came from Switzerland when he was 20 years old, going first to Watsonville. When he heard about the many horses that needed to be shod at Camp Atascadero, where the U.S. Army held summer war games, he came south. Cuendet worked for J. A. Wiebe for four years, bought him out, and then continued the business for 50 years. Not only was Cuendet a skilled blacksmith, which included crafting custom branding irons, he was also a wrestler. In 1912, he defeated a woman after she had beaten one of the other local men.

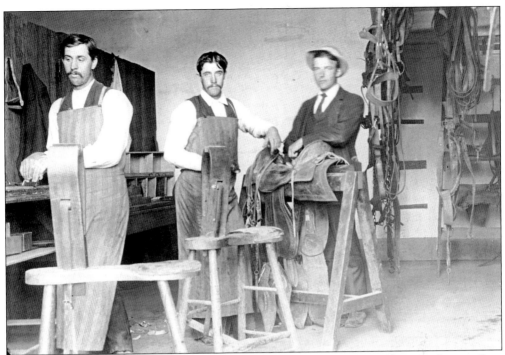

Brothers Franz (left) and Bert Morehouse (center) operated a saddle and harness shop on Pine Street between Twelfth and Thirteenth Streets. They are standing behind leather-stitching horses, which were used to hold leather together while the makers stitched the pieces by hand. Harnesses were essential for the many teams of horses needed to pull farm implements, carriages, and buggies.

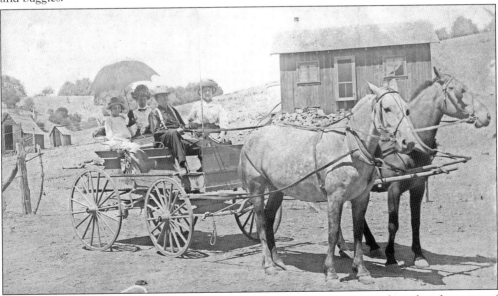

Chub and Buck are harnessed and ready to take the Lammon family to town from their farm west of Paso Robles, where the family settled after coming to California from Alliance, Nebraska, in 1913. The house (back right) was not yet finished when this photograph was taken. Pictured are Caleb W. and Glendora Lammon with their daughters Ila and LaViolette. (Courtesy Margaret Pemberton.)

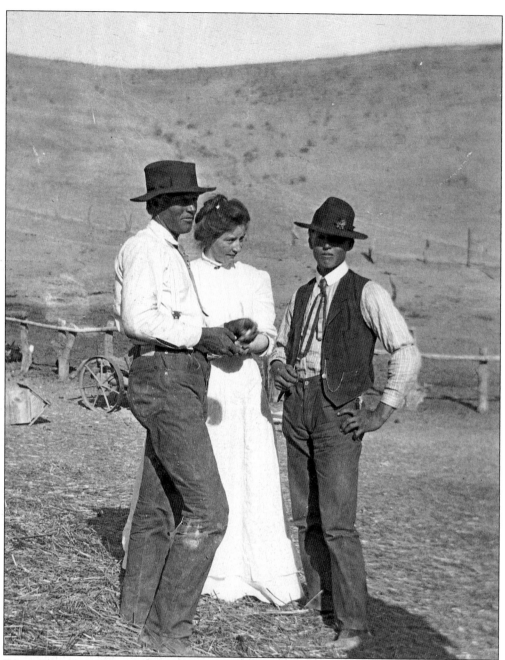

Emma Klauenberg (center) of Berkeley traveled by train to San Miguel to visit her cousins Johnnie (left) and Freddie (right) Von Dollen prior to 1910. The Johann and Caroline von Dollen family raised wheat and cattle on their 160-acre homestead (later enlarged to 480 acres), located 16 miles northeast of Paso Robles in Keyes Canyon. As with most homesteads, theirs had horses, chickens, a small orchard, and a garden where Johann grew watermelons, a tradition continued by his son Johnnie and his grandsons Fred and Arthur. (Courtesy Von Dollen family.)

"From sun up to sun down, a woman's work was never done." There were three substantial meals to cook daily on a wood stove, a garden and house to maintain, clothes to wash, and much more. Monday's wash day often began with carrying water from a nearby spring or well, heating the water over a wood fire, shaving chips of homemade soap off the bar into the hot water, and scrubbing the clothes. Emma Klintworth (pictured) was fortunate to have a "modern" washing machine to use around 1919. (Courtesy Violet Ernst.)

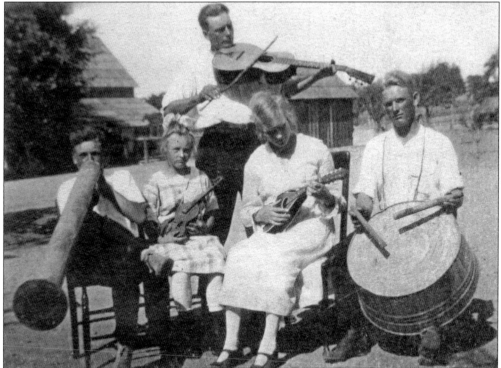

Although families worked very hard, it was not "all work and no play." Sunday was usually a day of rest from the demands of farm life. After the chores were finished in the morning, many families attended church services, ate a large dinner, and then relaxed some before starting the evening chores. The Klintworth family from left to right includes Bill, Minnie, Fritz, Mary, and Chris (playing the washtub/drum) enjoying an afternoon of music around 1915. (Courtesy Violet Ernst.)

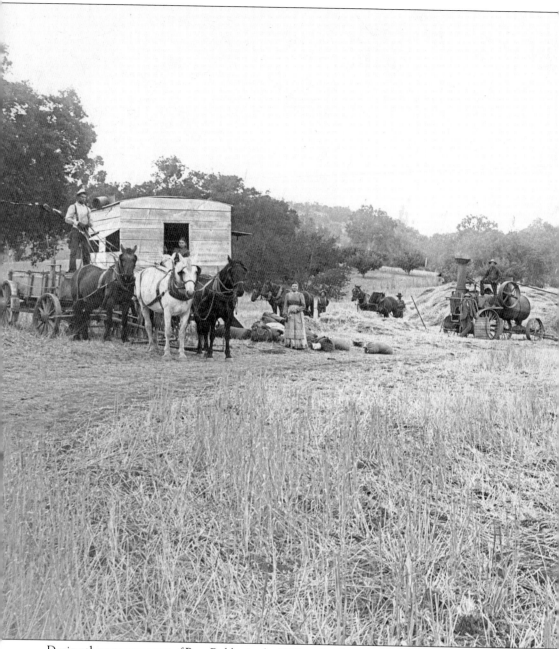

During the summer, west of Paso Robles in the Willow Creek area, Jacob E. Claassen's crew traveled from farm to farm to thresh wheat. The wheat was cut by a header pushed by horses, and the stalks were elevated by conveyor belt onto a wagon that traveled beside the header. The loaded wagon was brought to this site, where the grain was threshed by a stationary thresher (center right). By means of an elevator and chute, the grain was delivered into the separator parked alongside. The threshed grain was then sacked and the sacks sewn shut with twine. A pile of full grain sacks can be seen to the right of the thresher. The stationary thresher was eventually replaced with a combine, which could be pulled through the fields and which was so named because it "combined" the operations of a stationary thresher and a header. Pictured in 1902 on Martin Hultquist's farm

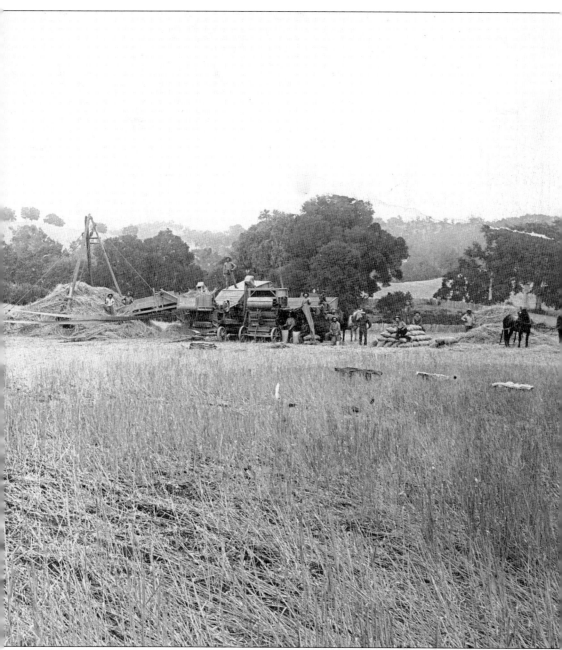

from left to right are Erhard H. Schroeder, water buck, standing on the water wagon; 17-year-old Agnetha Schroeder, cook, looking out the cook wagon's window; Eliza "Else" Claassen, cook; John O'Hollerin, derrick man; Harry Kahl, fireman; John Schroeder, in front of the Case steam engine; Abraham Claassen, engineer, standing on top of steam engine boiler; Louis Garcia, first forker; unidentified, second forker; Mark Maria, first hoedown (a person who raked the stalks of grain into the threshing machine); John Weir, second hoedown; Henry Claassen, separator man, standing on top of threshing machine; Martin Hultquist, beside the separator; Jake Wiebe, sack tender; Harry Williams, sack sewer; four unidentified people; and Herman Thimm, straw buck. (Courtesy Harold A. Franklin.)

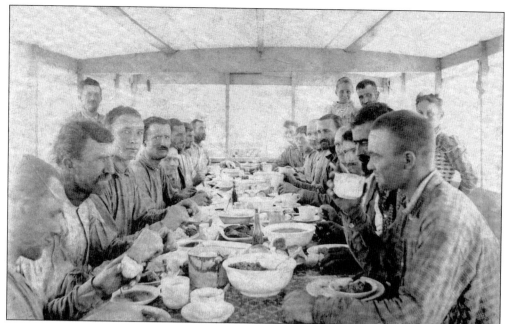

Near Shandon in 1901, G. W. Kilburn's threshing crew enjoyed some relief from the hot sun while eating dinner in their mobile dining room. The crew included the usual engineer, fireman, separator, forker, sack sewer, water buck, cook, and others. George Hansen Sr.'s (seated third from left) job was to pull the straw out of the way with a long plank as it built up behind the stationary thresher. (Courtesy George Hansen Jr.)

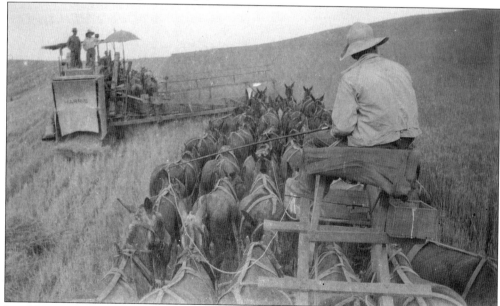

Iver Hansen (right) drove a team of 32 or 33 mules in Sheid Canyon near Shandon in 1927, pulling the heavy, wooden Harris combine through the wheat field. The combine's header topped the stalks, and a conveyor belt carried them up onto the harvester, where they were threshed and where the grain flowed into sacks. The straw was held and dumped out the rear. (Courtesy George Hansen Jr.)

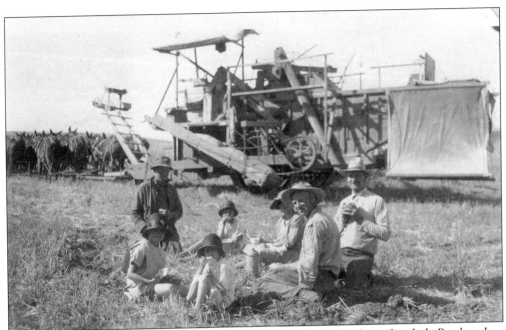

Harvesting crews worked long hours, starting before daylight and ending after dark. Brothers Iver and George B. Hansen Sr., working for Hans Aaroe in Sheid Canyon, take time out for coffee brought to them by Aaroe's wife, Anne, accompanied by daughters Gladys, Myrtle, and Violet. Shown around 1927, from left to right, are Gladys Aaroe, unidentified, Violet Aaroe, Myrtle Aaroe, Anne Aaroe, and George B. Hanson Sr. (Courtesy George Hansen Jr.)

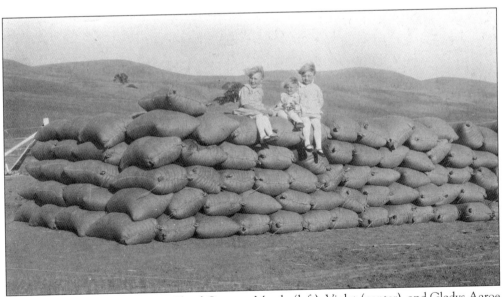

On a windy day around 1927 in Sheid Canyon, Myrtle (left), Violet (center), and Gladys Aaroe pose atop the results of the summer's labor—140-pound burlap sacks of wheat ready to be hauled to market. Bins on combines eventually eliminated sacks; as grain was harvested, it flowed directly into the bin. From the full bin, the grain was then augered into a grain truck. (Courtesy George Hansen Jr.)

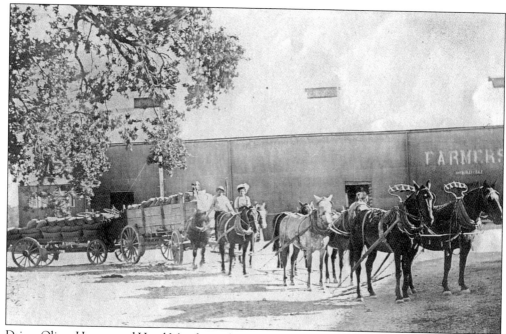

Driver Oliver Hopper and Hazel Morehouse have a load of grain to deliver to the Farmers Alliance Building in Paso Robles around 1910. Note the bicycle on top of the second wagon. Attached atop their collars, sets of harness bells on the two lead animals would warn an approaching team of their presence as well as set up a rhythm so the driver could determine if the team was pulling efficiently. (Courtesy Ellen Schroeder.)

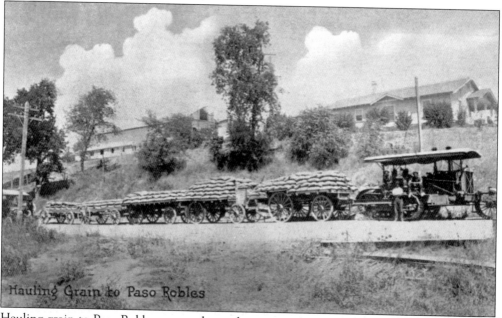

Hauling grain to Paso Robles was made much easier with the invention and use of a tractor. This 1917-era Holt 75 tractor on Cliff Road, now South River Road, pulled five heavy wagons—each loaded with four to five tons of sacked grain—to market in Paso Robles. (Courtesy Bonnie Nelson.)

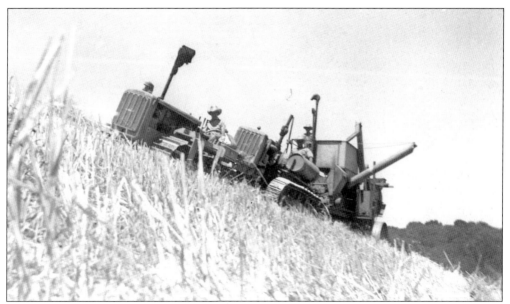

On the steep hills west of Paso Robles, this combine needed to be pulled by two tractors. In the summer 1948, 11-year-old Merle Miller drove the first one, a Caterpillar D-2; Miller's dad, Floyd, drove the second, a Caterpillar 30; and Miles Barlogio tended the header on the Caterpillar 38 combine. Instead of going into sacks, the barley went into the combine's bin. (Courtesy David Barlogio.)

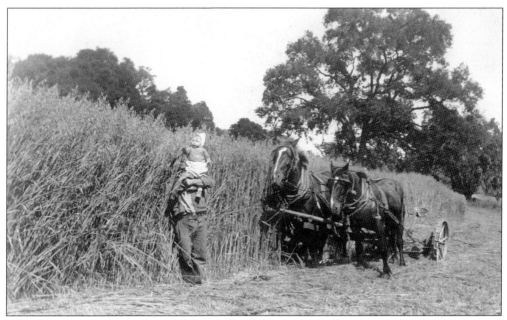

Miles Barlogio cut some tall oats and paused to hold up his son David in the York Mountain area west of Paso Robles in 1935. Barlogio made oat hay to feed his workhorses and the family milk cow. After the cut oats cured, he raked them, put them into large piles (shocks) using a pitchfork, baled them, and then stored the bales. (Courtesy David Barlogio.)

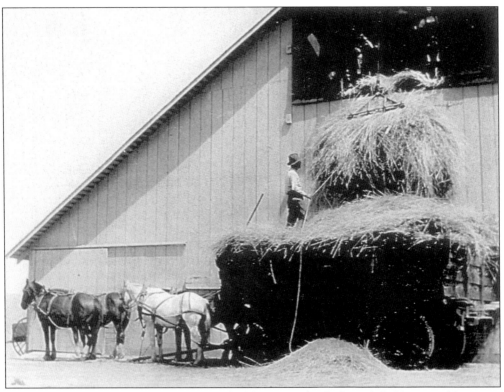

Before bales, hay was stored loose in a barn by lifting it with a Jackson fork. Using a cable system and track along the top inside of the barn, a forkful of hay was pulled up into the barn by a horse outside the opposite end of the barn. The hay was then dumped and the fork pulled back out of the barn and down into a wagon. The cycle was repeated until the wagon was empty.

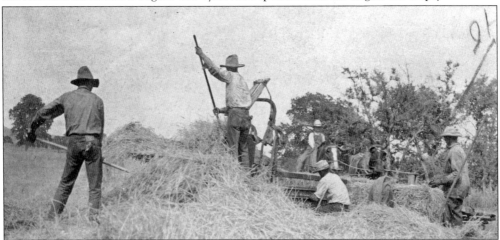

Hay forked to a stationary baler was pushed down by a "Chinaman," which tamped the hay into a cage where it was compressed by a plunger. Hitched to a power sweep with a set of gears, two or four horses walking in a circle powered the baler. A flat, wooden block, used to separate bales, had slots where baling wire was poked through by one person. A second person on the other side of the baler tied the wires together as the bale moved slowly past. Baled hay was easier to load, transport, and store than loose hay. (Courtesy Bonnie Nelson.)

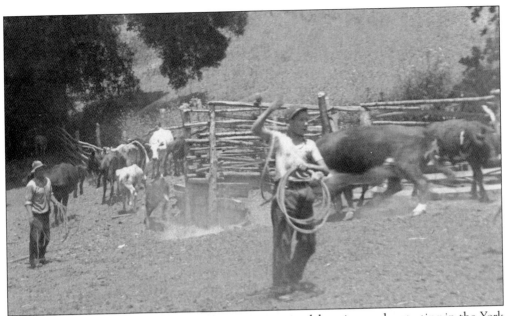

These cattle were rounded up for branding, vaccinating, dehorning, and castrating in the York Mountain area west of Paso Robles. Miles Barlogio watched in 1936 as Vernon Soto prepared to rope a young calf. The loading chute and corral were made of readily available pepperwood branches. Barlogio peeled the branches to make them last longer and tied them together with old telephone wire. Times were difficult, and farmers and ranchers made do with whatever was available. (Courtesy David Barlogio.)

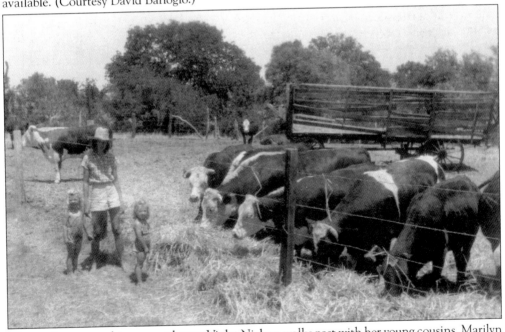

The cattle are munching on oat hay as Violet Nielsen walks past with her young cousins, Marilyn (left) and June Klintworth (right), southeast of Paso Robles in the Creston area in the early 1940s. The cattle belonged to Marilyn and June's father, Bill, and his brother Chris. (Courtesy Violet Ernst.)

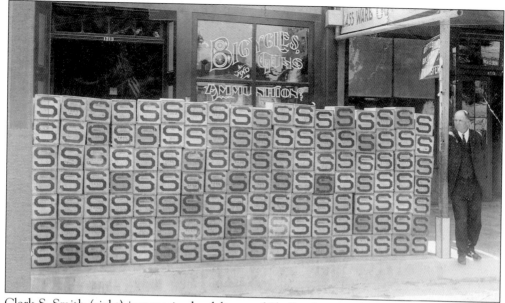

Clark S. Smith (right) just received a delivery of Shelby shotgun shells at his sporting-goods store on Park Street. Around 1915, Smith sold more ammunition per capita than any other store in California. Bird hunting was popular, and hunters supplied birds—doves, quail, pigeons, and ducks—for local restaurants. At the end of the first day of hunting season, barrels loaded with wild game were shipped to San Francisco. (Courtesy Smith/Wimmer.)

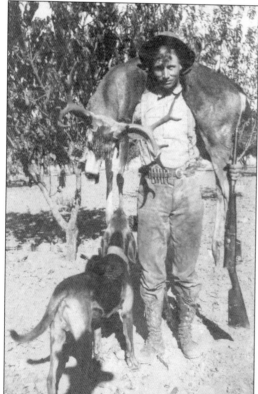

Clark S. Smith sold rifle ammunition used by deer hunters. Not only was deer hunting a sport, it helped put meat on farmers' tables as well as controlled damage to crops and lessened competition for cattle feed. K. B. Nelson carries in the buck that he shot some time in the 1920s east of Paso Robles. (Courtesy Bonnie Nelson.)

In the wide-open spaces on the Alfalfa Camp Ranch, about 16 miles east of Paso Robles, sportsman Clarence Dayton Hillman Sr. (center) and his sons (from left to right) Charles, Wayne, Homer, and Clarence Jr., show off their trophies after going on a hunting expedition around 1916. There was a bounty on coyotes, and they had shot two. (Courtesy Gee Gee Mainini.)

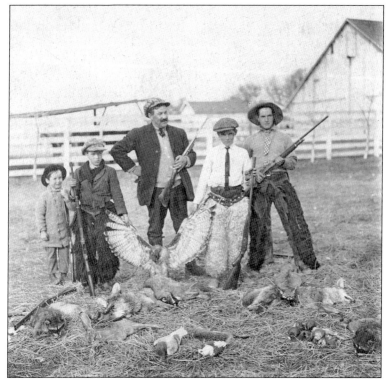

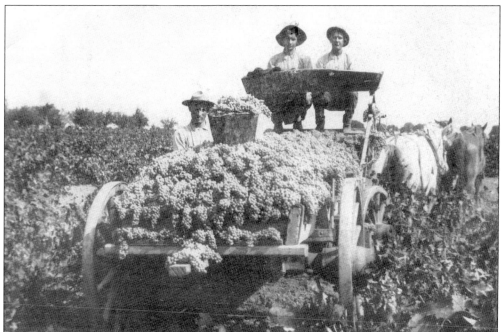

Brothers Henry (left), Fritz (center), and Chris Klintworth are pictured about 1913 on their father's ranch east of Paso Robles after they had just picked a load of grapes. Grapes were also grown west of Paso Robles in the vineyards of the Pesenti, Dusi, Rotta, and York families. (Courtesy Violet Ernst.)

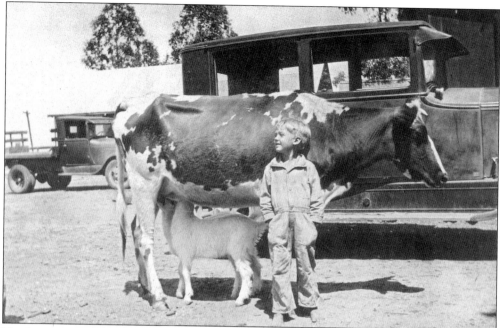

Nearly every rural family had a cow that provided milk, cream, and butter for its needs. In the early 1930s, Arthur Von Dollen poses with the family milk cow, which shared its milk with two young goats it had adopted. When the goats were young, they placed their front feet on an overturned washtub in order to reach the cow's udder. As they grew older, they also climbed on top of the family's Buick or anyone else's car that might be nearby, causing the owners concern about the cloth tops used on older cars. (Courtesy Arthur Von Dollen.)

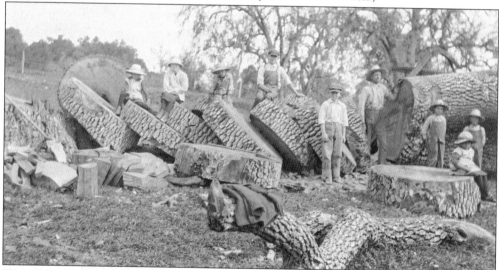

West of Paso Robles in the Willow Creek area, around 1924, Abraham Claassen uses a gasoline-powered drag saw with a six-foot blade to cut up a huge tree on the Jantzen farm. Firewood was essential for cooking and heating. Claassen (standing by tree) cut the wood for the Willow Creek Mennonite Church's pastor, Rev. F. F. Jantzen, as Jantzen's family, (from left to right) Minna, Mary, Anna (wife), Richard, John, Lubin, Ruth (seated), and Anne, looked on. (Courtesy Harold A. Franklin.)

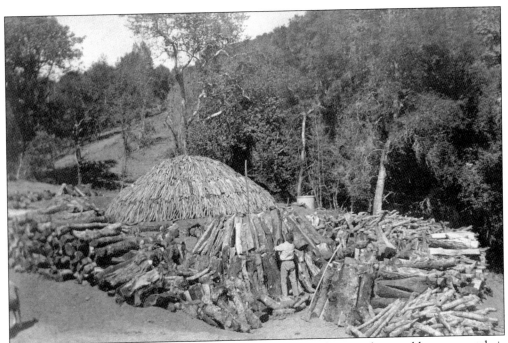

During the Depression, farmers had to be versatile and did whatever they could to support their families, including burning charcoal to sell. Giacomo "Jim" Busi (above), an Italian, burned charcoal with his Swiss neighbor, Miles Barlogio, in the mid-1930s west of Paso Robles. They covered a dome-shaped pile of wood with two layers, one of straw and one of dirt, to seal it. Vents regulated how fast or slowly the wood burned. After the fire was started, dirt was tossed on any leak to limit the oxygen, or the entire pile would become a bonfire. It took about one month to burn a mound, or pit, of charcoal. Two cords of wood (about eight tons) yielded one ton of charcoal. The Japanese burned charcoal using a large, airtight oven built into a hillside, the type still used by Busi's son Atillio. (Courtesy David Barlogio.)

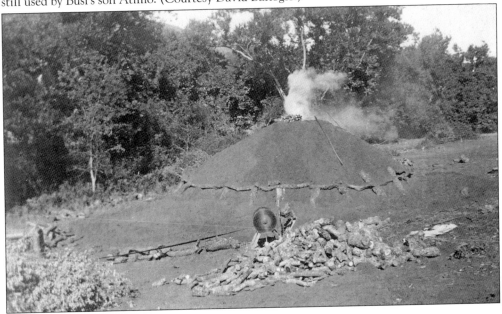

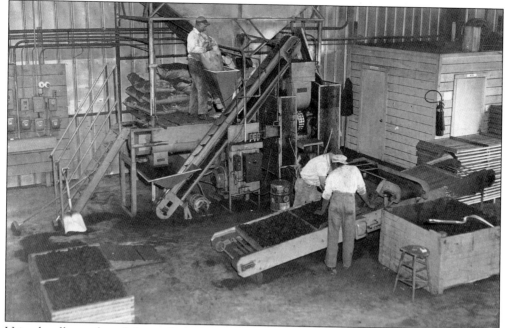

Using locally purchased charcoal, Art Trussler and his son Bill started making charcoal briquets in 1954 at this plant across from Paso Robles Cemetery on Lake Nacimiento Road. Kay Holloway is dumping cornstarch, used as a binder, into the hopper. The cornstarch, along with water, held the ground charcoal together. Two men are spreading the briquets out on the conveyor belt for drying. The briquets were shipped primarily to the San Francisco and Los Angeles areas.

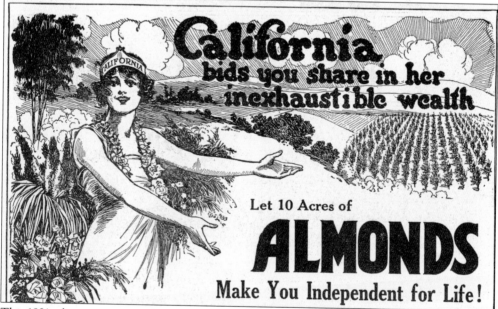

This 1921 advertisement, used to entice prospective investors to Paso Robles, shows the "glorious" reasons for owning almond acreage: residing in gorgeous Paso Robles and making a living at the same time. Their promotions worked, because over 10,000 acres of land went into producing almonds. (Courtesy Sunset Magazine.)

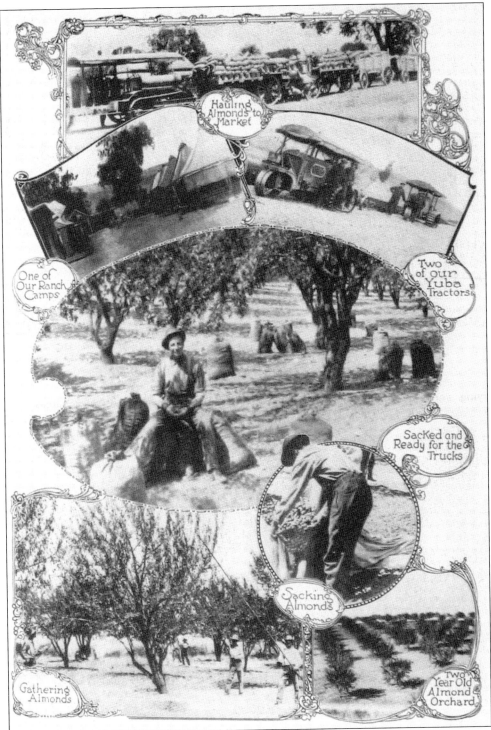

Many brochures promoting almonds lured potential buyers into purchasing 10-acre parcels. One brochure stated, "It [the almond tree] is long lived. A profitable production of nuts should continue for one or two centuries." (Courtesy Paso Robles Public Library.)

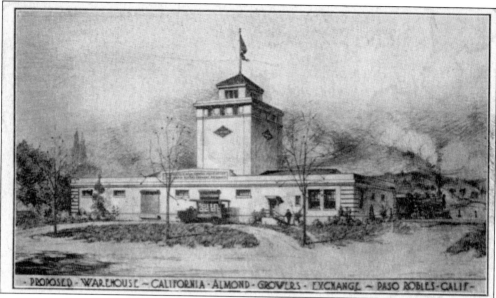

In 1910, the Paso Robles Almond Growers Association was formed with six members owning less than 60 acres of orchard to furnish a common and central marketing agency. In 1922, the association built this $70,000 warehouse close to the railroad tracks for expeditious shipping. When almond production declined, the building was vacated, and it was purchased in 1936 by the Farmers Alliance Association, who dealt in grain—storage, shipment, buying, and selling. (Courtesy Smith/Wimmer.)

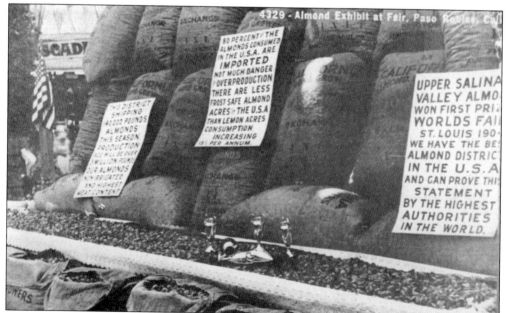

In 1919, an exhibit at the local fair promoted the almond-growing district, which shipped 140,000 pounds of almonds that season and expected over three million pounds to be produced the next year. The unirrigated almond trees produced small nuts, which were in demand by candy and other manufacturers. Early grower Michael Gerst could be proud of his blue-ribbon nuts, exhibited at the St. Louis Exposition in 1903. (Courtesy Dot Lefebvre, 1890 House.)

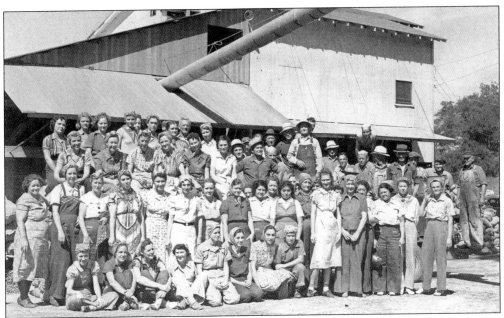

This almond crew gathers about 1937 in front of Slate's processing, packing, and marketing facility on Adelaida Road (now Nacimiento Lake Drive). Frank and Mina Slate purchased a small almond, walnut, and prune orchard in 1924 and moved to the property in 1931. Then they added acreage and built a plant. After expanding their nut business to nationwide sales, they outgrew this original plant and relocated to a new facility at Fourth and Spring Streets in 1947.

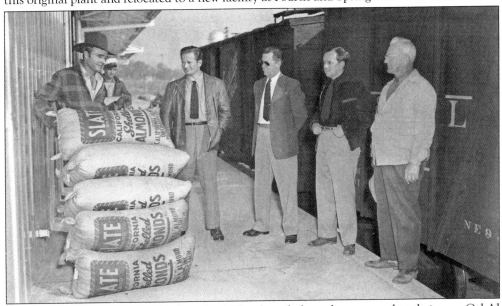

An unidentified employee is ready to load Slate-brand almonds, processed at their new Cal-Al (California Almond Orchards, Inc.) plant, onto freight cars. Watching in 1947, from left to right, are Lewis L. Slate, Harlow B. Ford, Joe Meyer, and Frank P. Slate. Although Cal-Al expanded over the next 20 years, local production had declined by 1950. The plant processed almonds from the San Joaquin Valley, where production was greater because of irrigation. The Paso Robles plant eventually closed, and the buildings were removed by the mid-1990s.

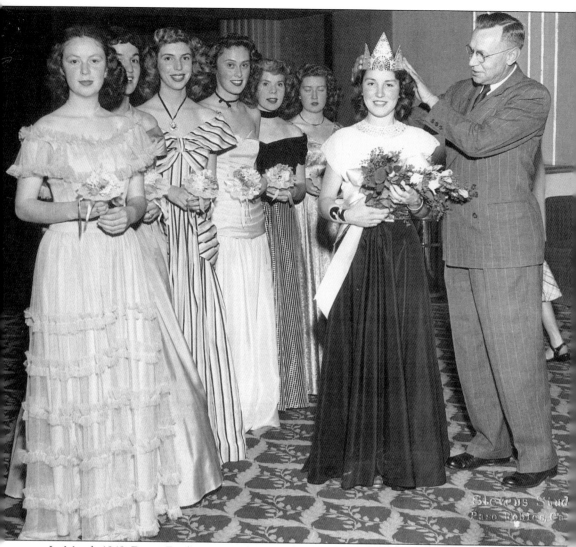

In March 1949, Diane Fowler was crowned queen of the third Almond Blossom Festival by the city's mayor Paul Turner at the T&D Theatre on Twelfth Street. The attendants, from left to right, are Nancy Tebow, Marianne Michels, Jean Hardie, Marlene Baumbach, Clara Moe, and Peggy Brooks. Almond Blossom Days, a local promotion for the almond industry, was scheduled for when the almond trees were in full bloom. However, with changing weather conditions, it was difficult to determine exactly when that would be, so the event was eventually discontinued. A few almond trees are still growing on the hillsides west of Paso Robles, a reminder of the days when Paso Robles was known as the Almond Capital of the World. (Courtesy Diane Fowler Hahn.)

Four

THE RICH HERITAGE
PADEREWSKI, PIRATES, AND MORE

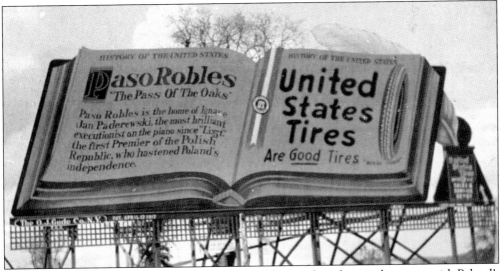

This 1931 billboard indicates the pride that Paso Roblans took in sharing their town with Poland's first premier, Ignace Jan Paderewski, who chose the area for his second home. He loved to visit his ranch, view the surrounding beauty, and stay with family and entourage at the Hotel El Paso de Robles, where his suite of three rooms was specially outfitted for his needs. Here Paderewski received much-needed rest and recuperation from his demanding U.S. piano concerts. Suffering from neuritis and arthritis during his 1913–1914 concert tour, Paderewski stated in his memoirs that he was advised, "You must go at once to Paso Robles and take some of the mud baths there for your arm. They are magical!" The baths provided relief from his pain, and within three weeks, he was able to continue his tour. Paderewski's playing was powerful, tender, and magnetic, with extraordinary tonal qualities. He was loved by the people of Paso Robles, not only because he was a great pianist, but also because he was a fine, warm, and intelligent gentleman. (Courtesy Paderewski Collection.)

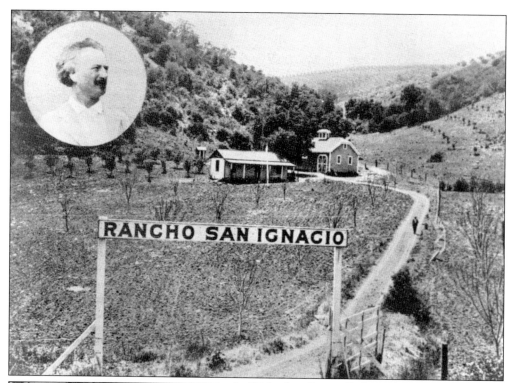

In 1914, when Ignace Paderewski visited the hot springs, he was persuaded by Dr. Frank W. Sawyer, the Hotel El Paso de Robles manager and a real estate agent, to buy land. Taking Sawyer's advice, Paderewski purchased ranchland, which he named Rancho San Ignacio, with its main entrance on what is now Peachy Canyon Road. The sign seen here shows another entrance on the south side of Adelaida Road, two miles west of Nacimiento Lake Drive. Later Paderewski bought property in the Adelaida area one mile past Rancho San Ignacio and named it Rancho Santa Helena after his wife. Paderewski stated that he was probably a willing victim, because he really loved those properties, which contained plenty of the healing waters. He planted hundreds of acres of almond, prune, and walnut trees as well as a Zinfandel vineyard. He said, "I loved Paso Robles before and after I bought it [the ranch]." (Courtesy Paderewski Collection.)

Form 1206A

WESTERN UNION

WESTERN UNION

TELEGRAM

CLASS OF SERVICE DESIRED

| Telegram |
| Day Letter |
| Night Message |
| Night Letter |

Patrons should mark an X opposite the class of service desired; OTHERWISE THE MESSAGE WILL BE TRANSMITTED AS A FULL-RATE TELEGRAM

NEWCOMB CARLTON, PRESIDENT GEORGE W. E. ATKINS, FIRST VICE-PRESIDENT

Receiver's No.

Check

Time Filed

Send the following message, subject to the terms on back hereof, which are hereby agreed to

18/II 1923

DR G W TAPE

PASO ROBLES CALIFORNIA

KINDLY WIRE SAN DIEGO PRIVATE CAR IDEAL CARE PULLMAN COMPANY
ADDRESS OF DOCTORS WHO ACCORDING TO YOUR ADVICE ATTENDED MY
HUSBAND IN LOS ANGELES STOP SEEMS TO ME ONE OF THEM WAS DR
BEATTY STOP SHALL BE PASO ROBLES MONDAY TWENTY SIXTH FOR A
WEEK HOPE ROOMS BE AVAILABLE FOR US TWO MISS LIIBKE TWO XXXXX
SECRETARIES AND VALET DELIGHTED TO SEE YOU AU REVOIR

HELENA PADEREWSKA

As seen in this 1923 communication, Madame Helena Paderewska telegraphed her needs to the hotel. Two years earlier, Aniela Strakacz, wife of Paderewski's secretary, arriving in Paso Robles with the Paderewskis, remembered that the sky was so fiery she thought the train station was burning up. Instead she discovered that the fire was from the many torches that the townspeople were carrying to greet the great pianist. (Courtesy Paderewski Collection.)

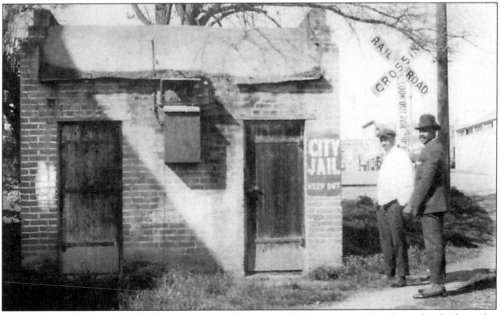

Two of Ignace Paderewski's Pullman porters, who managed his private railroad car, checked out the 10-by-13-foot city jail, used from mid-1889 until 1914. If a jailbird was smart, he could escape the brick structure and hop a passing train. However, most inmates were not smart. One dug through the wall of his cell only to find himself peering into the other cell. (Courtesy Paderewski Collection.)

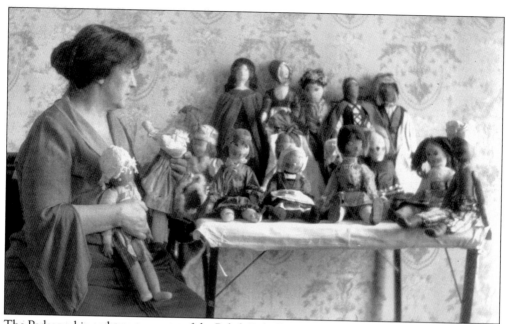

The Paderewskis, ardent supporters of the Polish Relief Fund, wanted Poland to be an independent country. Pictured in her hotel room, Madame Helena Paderewska raised funds for the Polish children by selling these Polish dolls and hosting teas and dances at the hotel. In 1921, it was reported that she had a card party, dance, and bazaar in the hotel's ballroom for fund-raising purposes and thanked the town for its help. (Courtesy Paderewski Collection.)

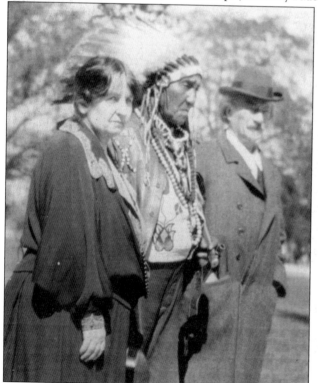

It is assumed that Madame Helena Paderewska (left) and Ignace Paderewski (right) are shown here with Big Tree, a Seneca Indian who acted in many movies. He was one of three Native Americans who posed for the composite image on the U.S. buffalo, or Indian head, nickel, produced from 1913 to 1938. The other two Indians who posed for the nickel were Two Moons, a Northern Cheyenne, and Iron Tail, an Oglala Sioux who fought at the Battle of the Little Big Horn in 1876. (Courtesy Paderewski Collection.)

This "statue" at the indoor plunge of the Hotel El Paso de Robles may have been of Madame Gorska, stepdaughter-in-law of Ignace Paderewski. The large plunge was fed directly from a spring that sent a constant stream of hot mineral water flowing into the shallow end. The deep, emerald-green water helped heal and soothe the body. In late June 1946, seventy-five community volunteers removed the roof and renovated the unused plunge for summer use, but the cool-water swimming pool at Ninth and Spring Streets became available and was used instead. (Courtesy Paderewski Collection.)

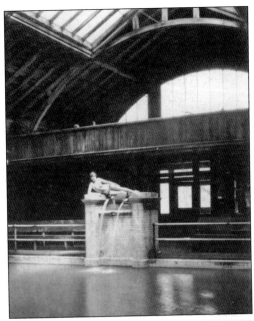

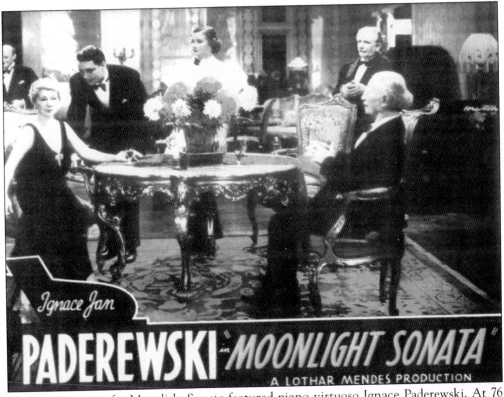

The movie poster for Moonlight Sonata featured piano virtuoso Ignace Paderewski. At 76 years of age in 1936 and starring as himself, Paderewski came out of retirement to make this sound movie in Denham, the Hollywood of Great Britain, near London. The scene depicts a Swedish castle. Moonlight Sonata was one of Paderewski's favorite Beethoven pieces. (Courtesy Steve Cichorsky.)

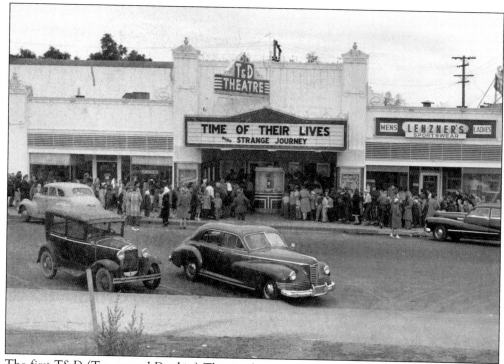

The first T&D (Turner and Dankin) Theatre featured a pipe organ and silent movies. When in town, Ignace Paderewski went regularly to the theatre, where the movie changed daily and twice on Sunday. Occasionally his wife accompanied him, hiding her little dog, Ping, under a blanket. This 1946 photograph shows a later T&D Theatre, built in 1930, on Twelfth Street. The movie *Time of Their Lives* was a sound production with Bud Abbott, Lou Costello, and Marjorie Reynolds. The theatre was demolished in 1957. (Courtesy Norma Moye.)

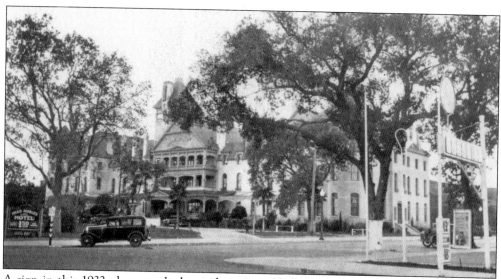

A sign in this 1932 photograph shows the price of lodging, $1.50 and up for a room, at the impressive Hotel El Paso de Robles. (Courtesy Chimney Rock Ranch files.)

The Pittsburgh Pirates had their spring training in Paso Robles from 1924 to 1934. The ballpark they used on Spring Street between Fifth and Sixth Streets had been used earlier by the Chicago White Sox. (Courtesy Smith/Wimmer.)

OFFICIAL
SCORE CARD
AND SOUVENIR PROGRAM

PITTSBURGH
PIRATES
SPRING
TRAINING SEASON

On Grounds Owned By
Paso Robles Fair & Athletic Association
Paso Robles, California

1927

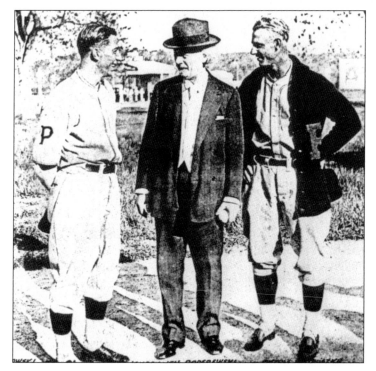

Paso Roblans, including Ignace Paderewski, enjoyed having the Pirates train in their town. Around 1931, Polish-born Paderewski (center) enjoys the camaraderie of two Pirates who shared his heritage: Adam Comorosky (left) and Tony Piet (right), whose name was changed from Pietruszka to Piet for the benefit of the press. (Courtesy Paderewski Collection.)

85

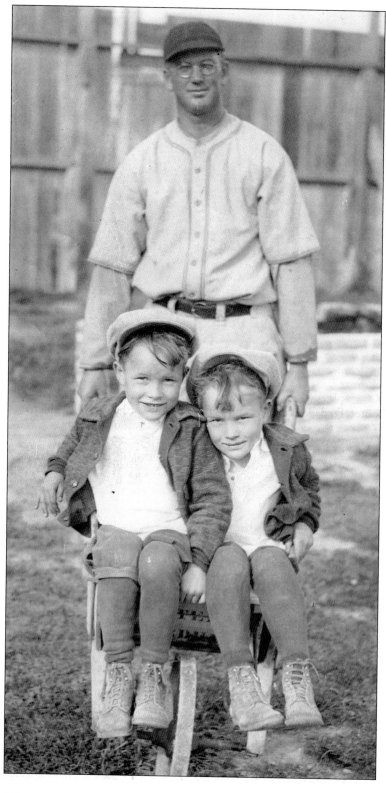

Twins Hillis and Henry Schinbine, local batboys, are getting a wheelbarrow ride from Pirates pitcher, Lee Meadows. Other boys shagged balls that were hit over the tall fence. If the boys returned three balls to the team, they earned 10¢—enough to go to the movies. Every day the Pirates jogged from their headquarters at the hotel to the ball field with neighborhood children chasing them and hoping for autographs or baseballs. (Courtesy Hillis Schinbine.)

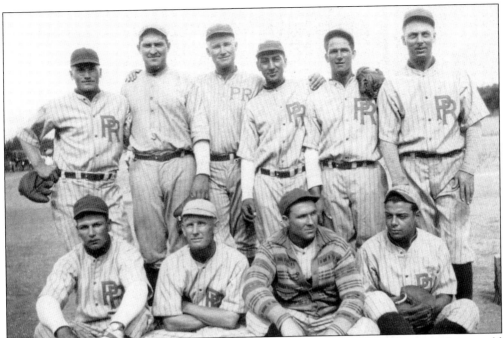

The Pirates played hometown teams to hone their skills for the national teams they would compete against. Chris Klintworth, member of the Paso Robles team, remarked that although his team maintained a good track record, he was not sure there was enough competition for the Pirates. The 1927 Paso Robles players, from left to right, are as follows: (first row) Lupe Higuera, Chris Klintworth, Les Sauret, Fred Gaxiola; (second row) Bill Klintworth, "Big Boy" Holman, ? Lundquist, Mike Barba, George Brown, coach Carlson. (Courtesy Klintworth family.)

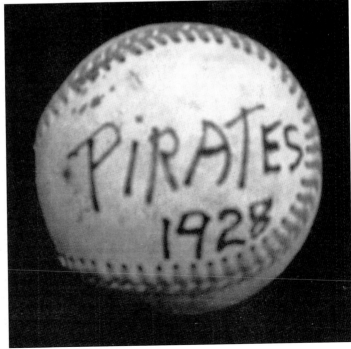

During this nation's golden age of baseball, Paso Roblans loved having the Pirates train in town. Fans flocked to the train station to meet the team when they came in. Getting an autographed baseball from the Pirates was sometimes difficult, as there were no ballpoint or felt-tip pens. Locating a pen, loading it with ink, and then inscribing the smooth "leather pearl" was not an easy task. This ball is on display at the Pioneer Museum.

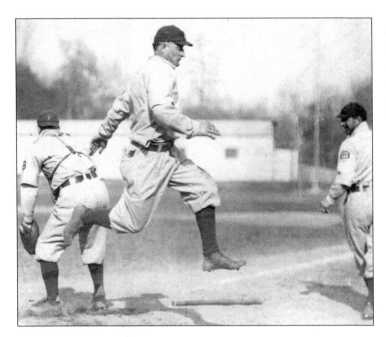

Although not of Dutch descent, Johannes Peter "Honus" Wagner (center) was nicknamed "The Flying Dutchman" because of his speed. He was inducted into the Baseball Hall of Fame in 1933 as one of the greatest all-around players, ending his career at shortstop with a total of 722 stolen bases. In 1932, Wagner became a coach for the Pirates and came to Paso Robles for the next training session. (Courtesy Carnegie Library of Pittsburgh.)

City leaders gathered in front of the hotel's bathhouse on September 19, 1929, to celebrate the arrival of natural gas in Paso Robles. Mayor Ellsworth Harrold turned on the gas into about 10 miles of distribution mains in the city, and Bob DeChaine lit the first flame. Prior to this, houses were heated either by wood-burning stoves or by furnaces fueled by stove oil. (Courtesy Smith/Wimmer.)

This mammoth, high-pressure silver tank was filled with natural gas from a 6-inch pipe laid in 1929 from San Luis Obispo to Paso Robles. Locals remember that boys, although not permitted to do so, would sneak to the top of the tank to get a great view of the ball games. This is Robbins Field between Sixth and Seventh Streets in 1935. (Courtesy Smith/Wimmer.)

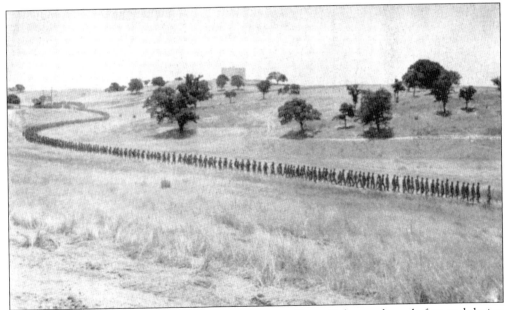

Soldiers are seen here parading to the target range at Camp Roberts where, before and during World War II, some 30,000 recruits trained every 17 weeks. In March 1941, Camp Roberts officially began its mission as one of the world's largest training sites. A total of 436,000 infantry and field artillery troops went through its intensive training cycle. It took more than 8,000 workers approximately nine months to construct the camp, 12 miles north of Paso Robles. (Courtesy Margaret Pemberton.)

Pictured standing by a recruiting truck is Mr. Simmerman, head of civilian personnel at Camp Roberts from 1941 to 1945. He and his staff hired many civilians for the various jobs that opened at the base between 1941 and 1944. Most Paso Roblans, and in particular businesses, wholeheartedly welcomed the soldiers. The base materially, socially, and permanently impacted Paso Robles, which increased in population from 3,000 to 8,000 residents. (Courtesy Camp Roberts Museum.)

Doing their part for the World War II effort, Paso Robles Senior Hi-Y Club members collected and sold waste paper, magazines, and cardboard to benefit the Red Cross. Pictured in their storehouse in 1942 are, from left to right, Bill Roberts, Donald Keefer, and Max Sears.

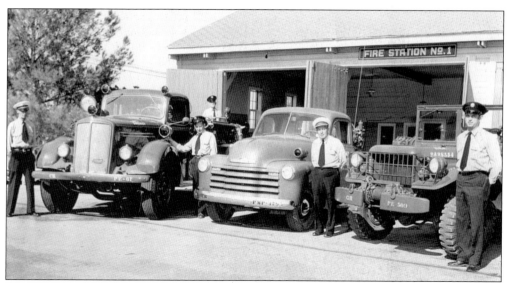

This fire station at Camp Roberts was supported by three other stations out in the infantry/training area. Depending upon the truck used, firefighters could pump 550 to 750 gallons of water per minute. The firemen are, from left to right, David Gatlin, unidentified, Vince Dailey, Gus Appuhn, and Bob Loy. (Courtesy Camp Roberts Museum.)

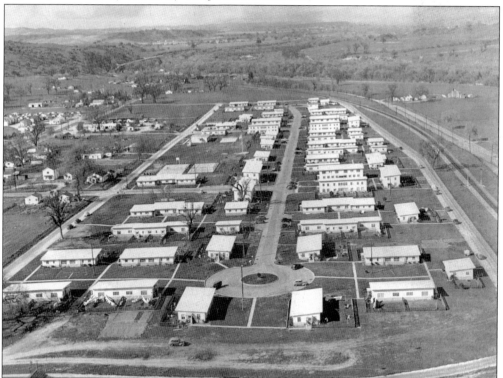

Oak Park, a government housing project completed in 1941 at the northern edge of Paso Robles, helped make room for families of enlisted servicemen during World War II. At one time, the housing situation was so dire that even some chicken coops were transformed into temporary living quarters. During 1940 and 1941, real estate prices increased 300 percent.

This August 1941 aerial view shows Sherwood Field after extensive improvements had been made to accommodate the 100-plus enlisted men and 20-plus officer-pilots. Tents were set up left of the checkered-roof hangar, which now houses Ennis Business Forms. In 1942, the Marine Corps acquired acreage and constructed a new (the current) airfield on Airport Road, called Estrella Field, where up to 1,500 troops trained. Following the war, with new housing encroaching on Sherwood Field, general aviation moved to the new field in the early 1950s.

In 1939, registered nurses Glen and Lena Mallory (left) opened the Paso Robles Community Hospital on Twelfth Street. At the end of World War II, while serving with the U.S. occupation forces in Japan, the Mallorys' dentist son, Jack, rendered dental services to Gen. Hideki Tojo, who was incarcerated in a Tokyo military prison. Jack retaliated by inscribing "Remember Pearl Harbor" in Morse code, carefully drilling the dots and dashes in the enemy's new false teeth. (Courtesy Jack Mallory.)

A ground-breaking ceremony took place in October 1948 for Paso Robles War Memorial Hospital on Terrace Hill, off Fifteenth Street. The state-of-the-art facility, with a spectacular view of the city, included a helipad. The hospital served the expanding needs of the community until Twin Cities Community Hospital opened in Templeton in 1977.

Robert Burke, the first patient admitted to Paso Robles War Memorial Hospital on January 2, 1950, suffered from a broken back. Nurse Lois Hoggbrin stood by to assist Drs. Frederick Ragsdale and James Scow as they applied a large cast.

Marian Poor, Claude T. Azbell, and Hiram Taylor established Paso Robles Auto Camp on the east side of Spring Street between Ninth and Tenth Streets. A June 18, 1926, review of the camp in the *Los Angeles Times* stated, "Here were hundreds of cars; hundreds of folks; hundreds of tents, scores of cabins, a store, a garage, equipment modern as any own-your-own apartment-house with laundry paraphernalia to make you gasp; electric stoves, cozy breakfast nooks, warm showers and a plunge." (Courtesy Dave Steaffens.)

Originally installed by the American Legion on Paso Robles War Memorial Hospital's flagpole, this memorial plaque paid tribute to the 24 local servicemen who sacrificed their lives for this country during World War II. In 1977, after the hospital closed, the local Lions Club moved the entire flagpole to the Paso Robles Pioneer Museum on Riverside Avenue.

Paso Robles Auto Camp's plunge, open to the public, was fed with water from a mineral spring. This auto camp was a one-of-a-kind facility, providing an alternative to staying in hotels in the days before motels came into existence. (Courtesy Dave Steaffens.)

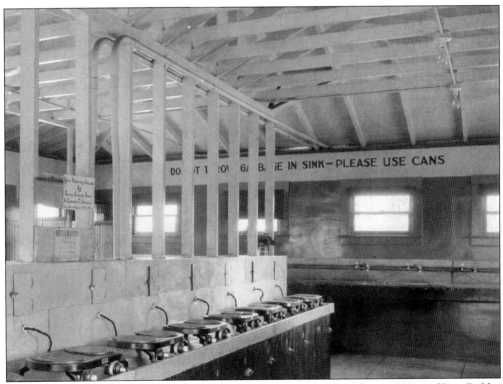

A community kitchen with two-burner electric hotplates was one of the amenities of Paso Robles Auto Camp in the 1920s. The sign's respectful wording (left) requests travelers to visit the nearby store, "Your Patronage Solicited by Camp Grounds Store." The store, open late into the night, offered food and necessities. Thus a traveler's needs could all be met at the auto camp. (Courtesy Dave Steaffens.)

Part of an early campground, the fuel pump and grocery store at Twenty-fourth and Spring Streets gave way to a new high school (now Flamson Middle School) in 1924. Campgrounds offered tourists an economical way to travel. Standing in the oak tree's shade, the proprietor appears to be taking a break between customers. Two miles west, another campground, Resthaven, offered camping, swimming, and groceries. (Courtesy Smith/Wimmer.)

Seen here in 1935, All American Café was located on Spring Street between Twelfth and Thirteenth Streets and was owned by brothers DeWitt and Henry Lyle. The building, which still stands, also served as the Greyhound bus depot until 1940, when the depot moved to larger quarters. (Courtesy Beverly Tornquist.)

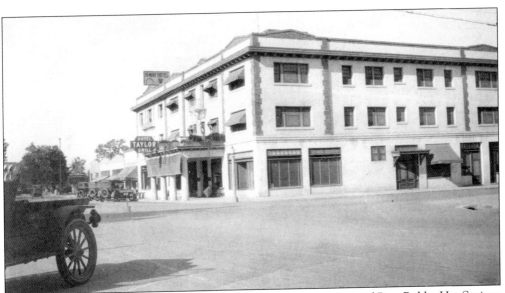

Hotel Taylor, built by Hi Taylor at a cost of $90,000 in 1918, was renamed Paso Robles Hot Springs Hotel in 1949. A fire destroyed it in 1963. A 1926 menu from the hotel's grill listed "Cooked to Order T-Bone Steak, $1.00" as well as an assortment of other entrees, side dishes, and desserts. Well-known actress Claudette Colbert was a guest in 1935 and exclaimed, "I love a small town like Paso Robles!"

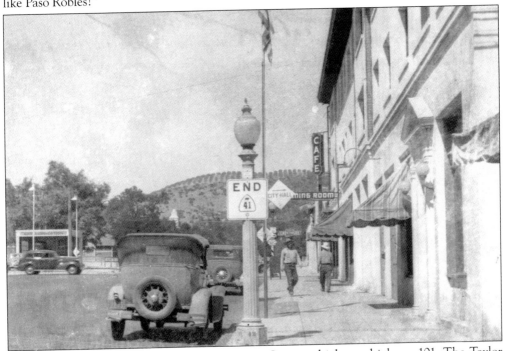

State Highway 41 from Fresno ended at Spring Street, which was highway 101. The Taylor Hotel (right), at the corner of Thirteenth and Spring Streets, housed the city hall until 1955, when it moved into a new building on Spring Street between Tenth and Eleventh Streets. The police department and jail were also here until they were displaced by the 1963 fire. (Courtesy Keith Tarwater.)

In 1955, brothers Robert "Bob" and Gerald Walters wait by the car while two customers place their orders. Polar Freeze was solely an ice-cream parlor until purchased by Lavern and Geraldine Walters, who added hamburgers and french fries. Polar Freeze was also a turnaround for teenagers who spent their weekend evenings cruising Spring Street during the 1950s and 1960s. The cruisers usually drove north from Polar Freeze to Wilson's Drive-in and then back. (Courtesy Lavern Walters.)

In 1948, Foster Freeze at 2524 Spring Street was established and continues to serve the community. JoAnn Karkanen, a senior at Paso Robles High School across the street, is pictured frying hamburgers in 1956. (Courtesy JoAnn Karkanen Trett.)

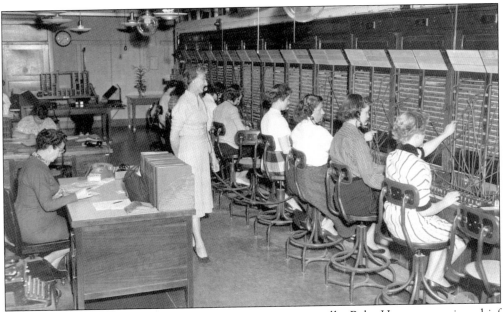

Telephone operators made switchboard connections manually. Babe Heaton, evening chief operator in the 1950s, is at the first (front left) desk, Margie Ventura is at the second desk, and Lucille Hibbard, chief operator, is standing. When local telephone service changed from manual to direct dial in 1960, the office was moved from Fourteenth Street to the corner of Fifteenth and Park Streets and into the newly constructed building housing the dial equipment. (Courtesy Marlene Heaton.)

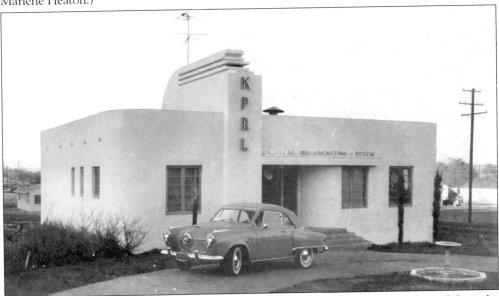

Established in 1947, KPRL, "Paso Robles Les," was named after the first co-owner of the radio station, Les Hacker. From 1952 to 1962, Dale and Barney Schwartz owned the station and won honors for news coverage in the area. When the city's fire sirens sounded, the newscasters interrupted programming to announce the fire's location. As they walked from house to house during the hot summers, mail carriers could hear the noon news through open windows—all the radio dials were set on KPRL's 1230 AM. (Courtesy Steve Cichorsky.)

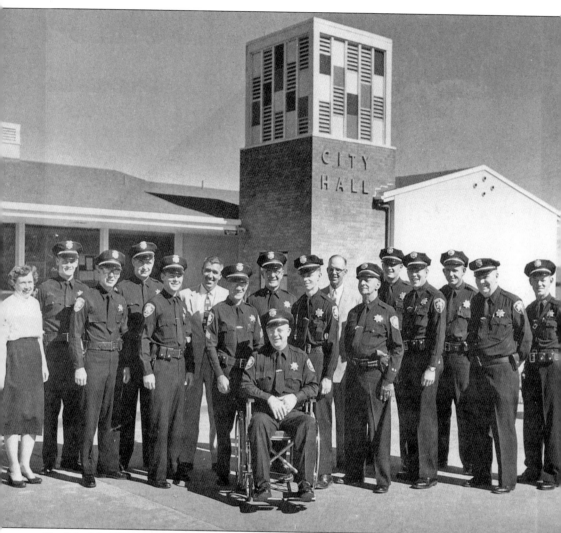

On July 20, 1957, Paso Robles Police Department personnel pose in front of the city hall on Eleventh Street. Pictured from left to right are secretary Alice "Miss Blue" Harris, Vern Mathison, Wade Richmond, Sgt. Lee Wilson, Ed Bryant, police commissioner Vernon Sturgeon, Sgt. O. B. Smith, Chief George Keller, dispatcher Marcus Tackitt (in wheelchair), Don Chamberlin, city administrator Sidney Tucker, Claude Jacques, Sgt. Earle "Bud" Requa, Henry Hillis, Dan Clark, Jim "Mac" McManis, and Capt. Orval Webber. After the 1963 Hot Springs Hotel fire displaced the police department and jail, the department had temporary quarters in a portion of the USO Building on Tenth Street while a former lumber company building (Builders Market) was being remodeled for the department's use. There were no jail facilities in the USO structure, so violators of the law who needed to be jailed had to be transported to San Luis Obispo. If a harmless drunk of no danger to anyone was picked up, the officers told him, "Go out on the front lawn and stay until you sober up."

Five

THE TRADITIONAL EVENTS
PIONEER DAYS, TRAIL RIDES, AND FAIRS

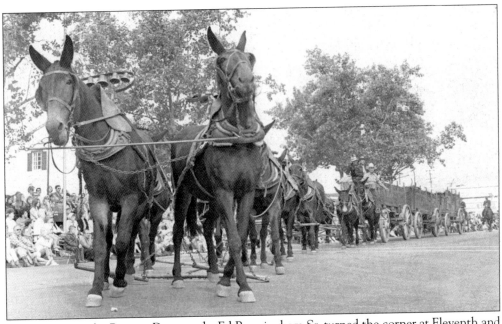

During the popular Pioneer Day parade, Ed Bermingham Sr. turned the corner at Eleventh and Spring Streets with his mule team, pulling wagons used for many years to haul sacked wheat into Paso Robles from the east side. His was one of many entries that represented the early days. A tradition since 1931, Pioneer Day was originally held on October 12, otherwise known as Discovery Day (renamed Columbus Day by Pres. F. D. Roosevelt in 1934). This celebration to remember the area's hard-working pioneers now takes place on the Saturday preceding Columbus Day. The parades of today are similar to the early ones. A 1940 program stated, "Today's parade . . . will depict the early life with the Indians; the founding of the West's chain of Spanish Missions; gold rush days; the struggles of the early pioneers who sought to wrest a living from what they as Easterners regarded as almost barren soil; the development of agriculture on a large scale, and finally, the advent of commerce and industry." From the parade's inception, all businesses except restaurants, service stations, and saloons closed to show their support for the unique day set aside to reflect on the community's history.

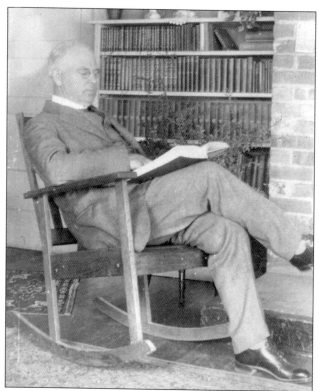

In spite of a heavy parish workload, the Reverend Charles L. Thackeray, rector of St. James Episcopal Church in Paso Robles, founded the first Pioneer Day as an opportunity for neighbors, friends, businessmen, and farmers to meet apart from the cares of the workaday world, and to picnic and enjoy the old-time fellowship typical of earlier America. Thackeray convinced the merchants, who realized that their existence depended upon the farmers and ranchers, to give them a yearly party where the guests paid nothing, thus the slogan, "Leave your pocketbook at home" fit. Thackeray led four successful celebrations before his untimely death in 1934. (Courtesy St. James Episcopal Church.)

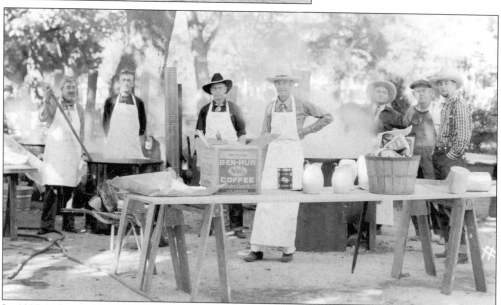

In 1935, volunteer firemen combined 600 pounds of meat, 3,000 pounds of potatoes, and nearly 300 pounds of tomatoes, carrots, onions, celery, turnips, and bell peppers for a giant stew served free to 3,000 Pioneer Day guests, compliments of the merchants. This 1937 photograph shows the cooks with their large pots. As crowds increased, the stew, prepared for six years from Roy Cammack's recipe, was replaced with a bean feed directed by the Paso Robles Lions Club. (Courtesy Shirley Tharaldsen.)

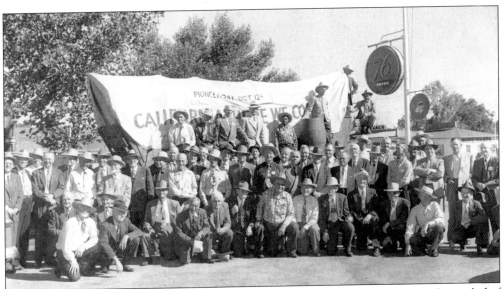

Honored annually with a luncheon, old-timers pose in front of a Conestoga wagon, the symbol of Pioneer Day. It was used for years as a freighter, traveling from San Francisco over Donner Pass to the Nevada goldfields. Built in 1862 and purchased in 1882 by the Patterson family of Lockwood (near King City), who loaned it for the first Pioneer Day parade, it is now a permanent part of the Pioneer Day Committee's collection. (Courtesy Wayne Jensen.)

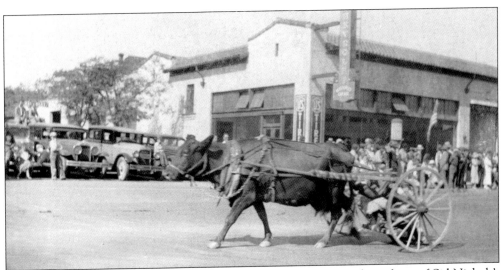

A harnessed cow pulls a two-wheeled cart through the 1934 parade in front of Sid Nichols's Chevrolet dealership at Thirteenth and Spring Streets. Pioneer Day provided an opportunity to display both the ordinary and the unusual. (Courtesy Violet Ernst.)

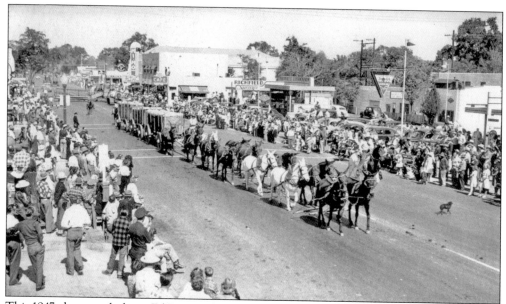

This 1947 photograph shows Ed Bermingham Sr.'s 14-mule jerk-line team pulling his grain wagons through the parade. The wagons were in the first parade and have been in every parade since. Until 1980, they were pulled by mules. As it became more difficult to get mules, the wagons were pulled by tractor. For the special 75th celebration in 2005, the Pioneer Day Committee imported a 20-mule team to pull the wagons through the parade. (Courtesy Judy Holsted.)

"Saturday Night Bath" was the theme of this 1950 parade float entered by the women's business sorority, Beta Sigma Phi. Dorothy Brooks Coates (left) and Barbara Bethel Lewin were on one side of the "wall" while the rest of the family waited on the other side for their turn to use the hot bathwater. The cleanest person usually used the water first, and then the other family members bathed. (Courtesy Dorothy Coates.)

The daughters of William and Dolly Bader, Barba and Susan, ride through the parade about 1951 in a pony cart. Both pony and cart had previously belonged to Rex Bell. Prior to arriving in Paso Robles, the pony had traveled extensively on land and by plane. The girls' mother rode a horse in the first Pioneer Day parade. (Courtesy Dolly Bader.)

Floats were decorated trucks, which usually backed down the parade route in order to display the float to its best advantage. Entries came from area Farm Bureaus, clubs, and schools. Geneseo School won the 1952 sweepstakes award with this "Family Photo" float. Eleven miles east of Paso Robles, the school was built in 1886 by German families. After the school closed at the conclusion of the 1961–1962 school year, the children attended school in Paso Robles.

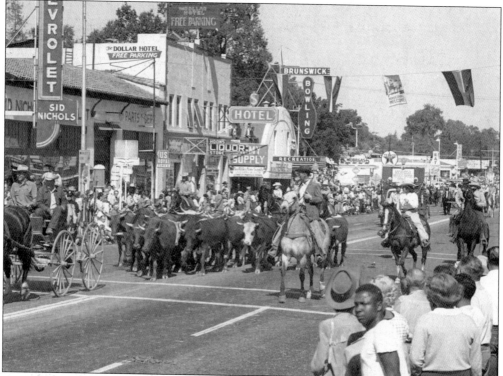

Cowboys are accompanying a herd of cattle on the 1953 parade route on Spring Street between Thirteenth and Fourteenth Streets. Six horseback riders made sure the cattle stayed on the straight and narrow.

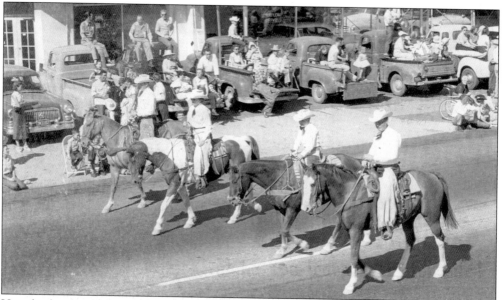

Horseback riders had an opportunity to show both their horses and horsemanship when riding through the parade. Pickups, used extensively on farms and ranches, served as excellent viewing platforms for spectators. (Courtesy Dolly Bader.)

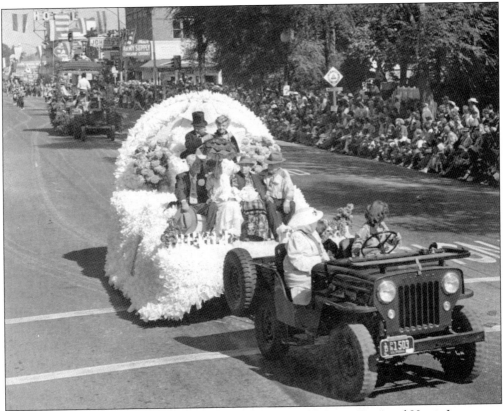

The local Quota Club entered this float in the 1953 parade. James "Jim" and Hettie Lemen are seated at the top of the float. Below them are Rollin "R. C." and Grace Heaton (left) and Willis and Zora Truesdale. May Tucker was in the passenger seat with Barbara Wilcox driving the Jeep. (Courtesy Marlene Heaton.)

In 1958, Queen Frida Ernst Knight (right) is seen here with her attendants, Ida Pepmiller Cammack and Georgia Brown. (Brown was honored in 1948 by having a Paso Robles school named after her.) A local lady and gentleman, descendants of pioneer families, are chosen by the Pioneer Day Committee to reign over each year's activities. A belle, usually a high school senior, is also chosen from pioneer families of the neighboring communities.

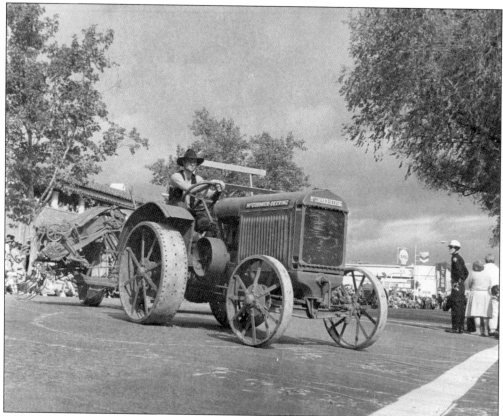

Sometimes referred to as a traveling museum, the Pioneer Day parade has continued to showcase pieces of antique farm equipment. Don Campbell, pulling a binder with his 10-20 McCormick-Deering tractor, is turning the corner at Eleventh and Spring Streets in front of the Paso Robles Inn. A binder was used to cut and bundle grain before it was hauled to a stationary thresher.

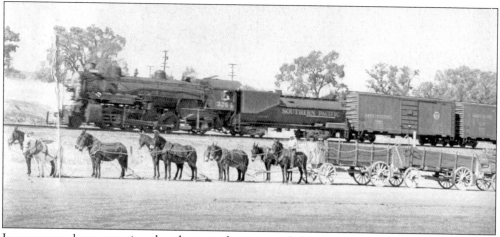

In an unusual opportunity, the photographer snapped this image in Paso Robles just as the Southern Pacific train was nearly even with the Bermingham team and wagons, which were headed for the 1958 Pioneer Day parade. (Courtesy Don Campbell.)

108

Before he became president of the United States, Ronald Reagan was in Paso Robles on a number of occasions. Seen here in the 1965 Pioneer Day parade riding Pancho from Chimney Rock Ranch, Reagan is part of the Pioneer Players' entourage, promoting their second annual production, *Annie Get Your Gun*. They are turning the corner at Twelfth and Pine Streets. (Courtesy Chimney Rock Ranch files.)

This 1950s photograph shows the Pioneer Day street dance held on Park Street between Twelfth and Thirteenth Streets. A 1935 article reported that 300 to 400 pounds of rice hulls were used to make the pavement slick. The building on the left, damaged by the 2003 earthquake, was replaced with a three-story structure in 2005. (Courtesy Norma Moye.)

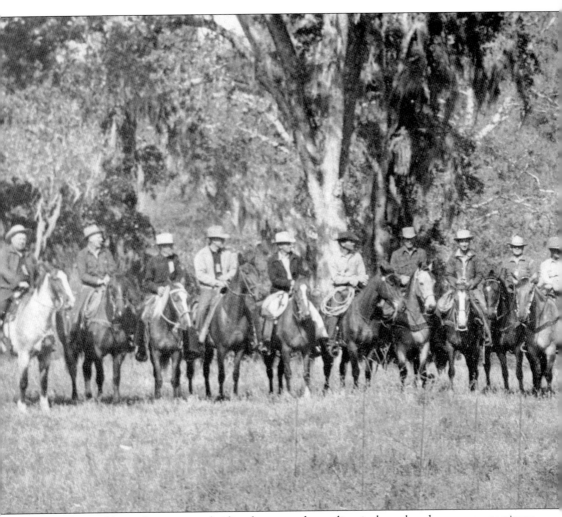

Men the world over have enjoyed riding horses and traveling in large bands over new territory for extended periods of time. The males of Paso Robles were no different from their predecessors. They liked horses and riding in the company of their friends and neighbors. A group of business and professional men, ranchers and farmers, and drugstore cowboys decided to take a journey with their steeds—mainly to see some of their county but also to engender goodwill and fellowship, to have clean recreation, and undoubtedly, to show off their horses, saddles, and riding ability. The first trail ride in April 1942, a four-day, three-night event, was enjoyed so much that the riders started planning a 1943 ride as soon as they returned home. On the first day, they rode 17 miles

on a variety of horses: bays, blacks, whites, sorrels, grays, chestnuts, browns, pintos, buckskins, and palominos. The charter members of the Paso Robles Trail Riders, with the exception of C. C. Thompson, the first president who was deceased when this photograph was taken in 1947, are, from left to right, Fred Wamsley, Emrie "Dick" Kleck, John Hardie, E. R. Griswold, Art Trussler, Tom Brown, Caryol Stockdale, Leon "Dutch" Kleck, R. W. "Bob" Mann, Carl Taylor, R. L. "Bob" Olden, Vic Palm, Carl Anderson, Dr. Alvin H. Wilmar, Charles Trussler, Jerry Brush, Dr. Fred Ragsdale, Dr. Lolen Strahan, Dave Stevens, Dr. Robert "Bob" Peachey, K. B. Nelson, and J. W. Wachtel.

The Paso Robles Trail Riders gather in the early morning hours near Paso Robles Agriculture Works at Twelfth and Pine Streets to gear up for the ride. Bedrolls and all kinds of equipment were loaded on the truck to be hauled to the first night's campsite. Sleeping gear ranged from blankets and canvas to fancy bedrolls and sleeping bags. (Courtesy Bonnie Nelson.)

Imagine their surprise when Vernon Nelson (left) and Don McMillan unrolled a horse blanket used on the previous year's trail ride, only to discover that mice had eaten large holes in it.

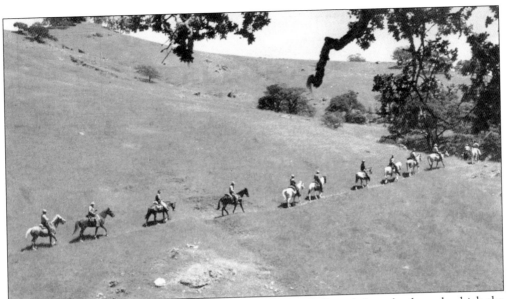

This is a typical countryside scene of the county's rolling hills and the oaks through which the trail riders passed. On their annual rides, the men traveled a variety of routes, such as American Canyon, Parkfield, San Simeon, Arroyo Grande, and Camp Hunter Liggett.

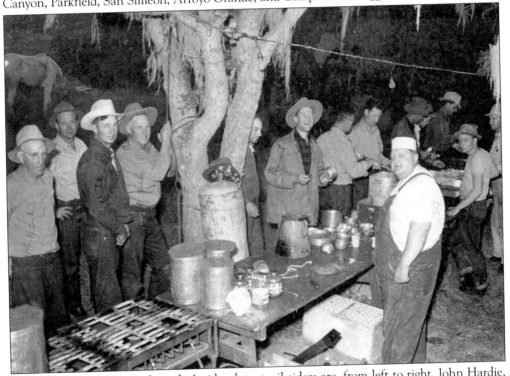

Lining up for grub after a long day's ride, these trail riders are, from left to right, John Hardie, unidentified, Leon "Dutch" Kleck, Emrie "Dick" Kleck, unidentified, Herb Reinert (holding cup), a 345-pound cook ("a living testimonial to his own cooking ability"), and other unidentified men. The cooking crew was well equipped with portable gas ranges, an electric-light generating plant, and lots of good food.

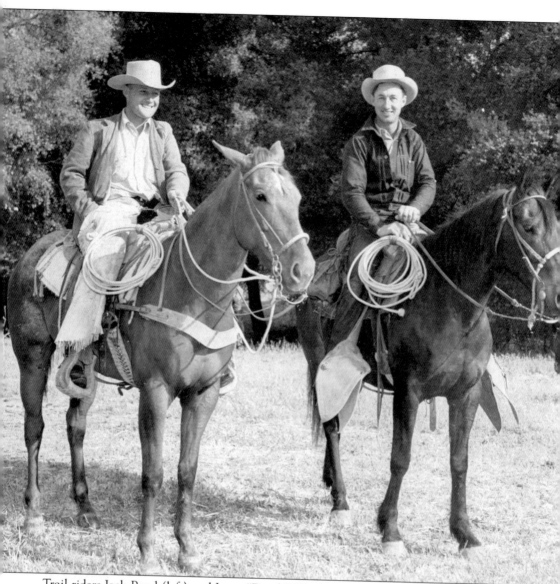

Trail riders Jack Pond (left) and Leon "Dutch" Kleck are ready to begin a day's ride in 1944. Another event for horse enthusiasts was, and still is, the local fair. A year before the first trail ride, the San Luis Obispo County Fair Association was formed, but because of World War II, the first fair did not debut until 1946. It is unclear how many fairs took place prior to 1946, but fairs were held in 1897 and 1899. An 1899 booklet *Fair Souvenir* showed categories for best harness; blacksmith work; homemade boots or shoes; and articles made from copper, tin, and iron. There was a show for the finest-looking baby between 6 and 12 months of age. The admission fee was 15¢ for adults and 10¢ for children. Another fair in 1912 contracted with an amusement company to bring seven riding devices and amusements that had been found "to be clean and moral." A ball and ceremony were held to crown the fair's queen. In 1916, another fair was held. These early fairs bore the title of Upper Salinas Valley Fair.

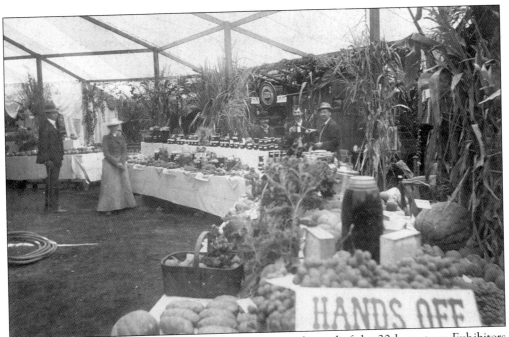

Fairgoers are admiring the displays in the city park at the end of the 20th century. Exhibitors showed items they grew, preserved, baked, and manufactured. (Courtesy Smith/Wimmer.)

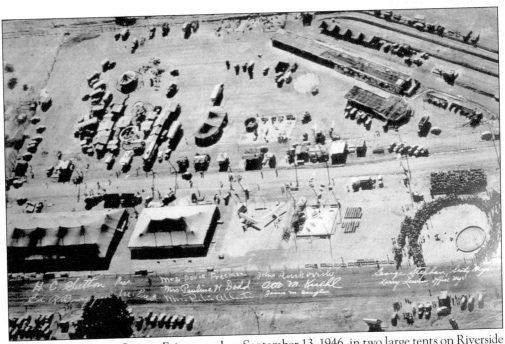

The San Luis Obispo County Fair opened on September 13, 1946, in two large tents on Riverside Avenue, under the direction of George Stephan, the executive secretary of the 16th District Agriculture Association. Other board members included Herbert C. Sutton (president), Ed R. Biaggini (vice president), Dovie Freeman, Pauline Dodd, Rubie Alberti, John Ruskovich, Otto M. Kuehl, and James M. Douglas. Larry Lewin was the office manager. (Courtesy Mid-State Fair.)

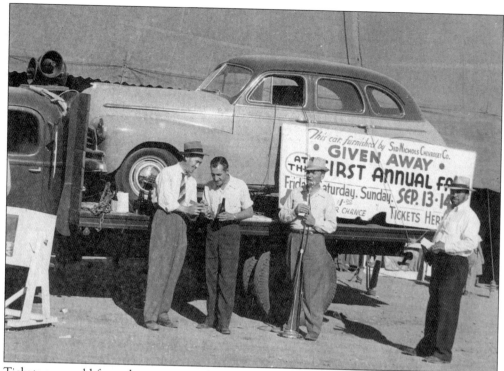

Tickets were sold for a chance to win this new Chevrolet, furnished by Sid Nichols Chevrolet Company in Paso Robles. The car was won by Pat Gileau, who worked for Charles "Charlie" Ashton and Thomas O. "Dick" Waer, local dealers for DeSoto and Plymouth. There were 20,000 people who attended the 1946 fair with its admission fee of $3.60 for the three-day event.

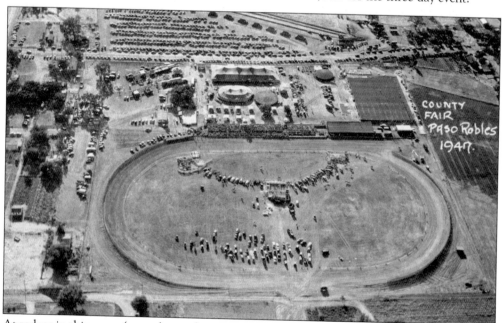

At rodeos in this arena (center), seen here in 1947, riders and ropers have entertained thousands of fair visitors. (Courtesy Bonnie Nelson.)

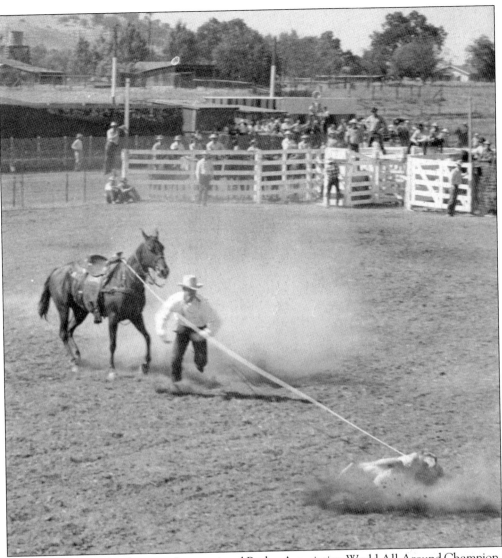

Cowboy Gene Rambo, four-time International Rodeo Association World All-Around Champion, shows his calf-roping skills at the Paso Robles rodeo with help from his horse Nita during the 1940s. Rodeos—where top cowboys vie for money in calf roping, bronco riding, bull riding, and other events—have had a long history in the United States. A rodeo was part of the 1946 fair. Rambo, a Shandon rancher, made the majority of his living from participating in rodeos during the 1940s and 1950s. (Courtesy Barbara Rambo.)

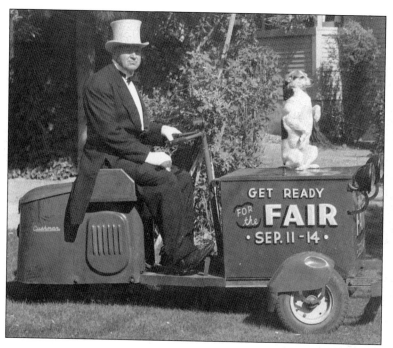

Dressed in a tuxedo and top hat, John Karkanen, accompanied by his dog Buddy drove this Cushman utility cart around downtown Paso Robles to promote the upcoming fair. Karkanen moved to Paso Robles with his family in 1944 and started working as a maintenance man at the fair a couple of years later. He used the cart to get around the fairgrounds. (Courtesy JoAnn Karkanen Trett.)

Templeton 4-H Club member Nancy Cook was featured on the front page of the *Paso Robles Press* on August 29, 1950, with her champion 4-H hog and its buyer, Julian Kern, who purchased it for the Paso Robles JCPenney Company. Throughout the years, animals raised by members of 4-H Clubs and Future Farmers of America chapters have been exhibited and auctioned off at the fair. (Courtesy Nancy Cook Lewis.)

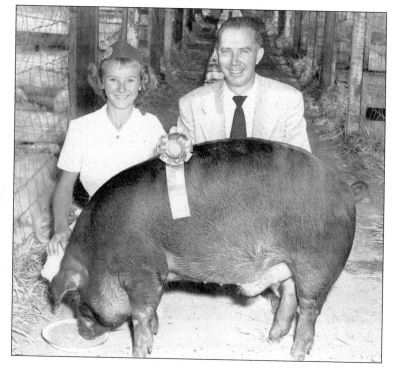

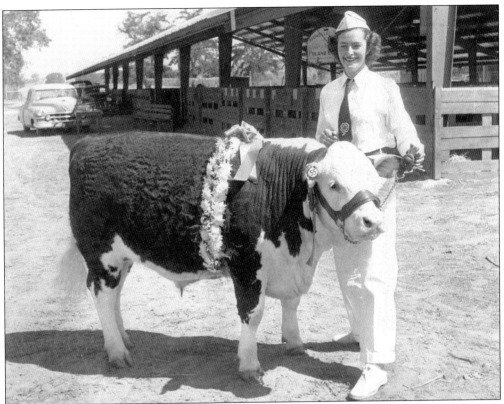

Raising animals and showing them has always been an important aspect of the fair's agricultural thrust. At the 1952 fair, JoAnn Arnold, a Pozo 4-H Club member, poses proudly with her champion 4-H steer, which sold for 95¢ per pound. (Courtesy Mid-State Fair.)

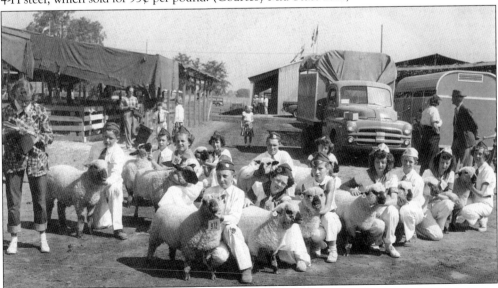

These 4-H Club members had their sheep groomed and ready to show during the 1953 fair. Twins Velma and Verna Lichti are to the far right, and Emily Bianchi is partially hidden in the second row. (Courtesy Velma Lichti Crowley.)

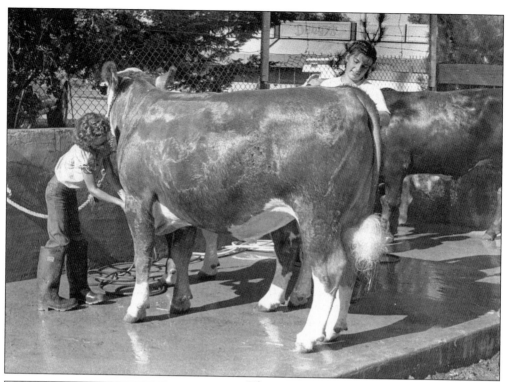

The young people worked hard to have their animals in prime condition for the fair. Getting an animal ready to show involves washing, brushing, fluffing its tail, and making it look its best. Some of the owners spent the night in the barns, making sure their animals were okay at all times. (Courtesy Mid-State Fair.)

SAN LUIS OBISPO COUNTY FAIR

LOUIE OBISPO

Louie Obispo was a familiar symbol of the fair for many years along with the slogan, "Biggest Little Fair—Anywhere!" Fairs originally ran for three days; in later years, the number of days fluctuated. The fair entertained and educated as well as showcased the county's Western heritage and agriculture. (Courtesy Mid-State Fair.)

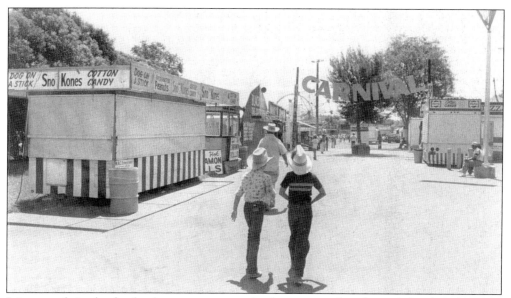

It is too early in the day for the snow-cone stand to be open, so these boys are heading down the midway to the carnival, where they might enjoy some rides or try their luck at winning a stuffed animal. (Courtesy Mid-State Fair.)

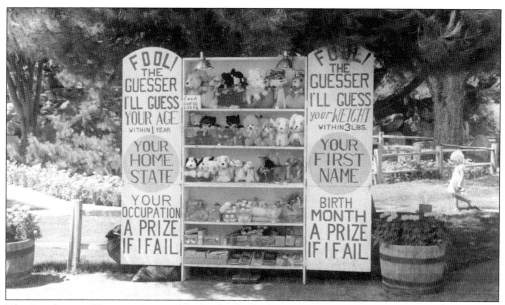

The "professional" guesser's portable display bade the passerby to stop and see if the "pro" could accurately guess age, weight, home state, birth month, occupation, and first name. The guesser offered a prize if he failed. (Courtesy Mid-State Fair.)

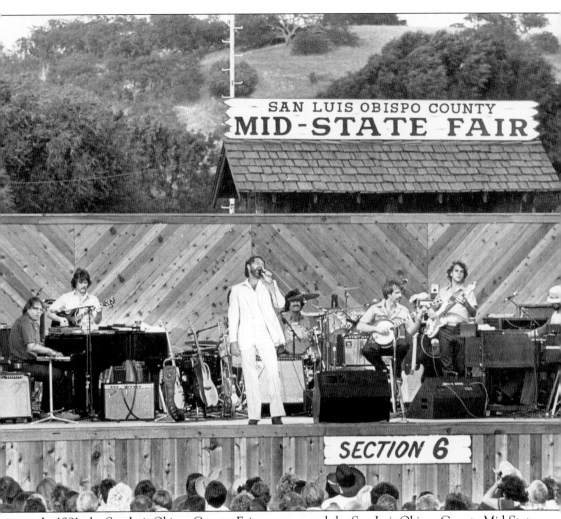

In 1981, the San Luis Obispo County Fair was renamed the San Luis Obispo County Mid-State Fair, and then it became the California Mid-State Fair in 1986. Although there is still an emphasis on agriculture, over the years well-known artists performing hit songs have been a huge draw for visitors. In 1946, some 20,000 people attended the fair. Records for 2006 indicate that there were 361,662 attendees. The entertainment for the first fair cost $3,000; in 2006, the entertainment costs were $2 million. The fair has grown through the years, from two large tents placed in the current parking lot to seven major buildings containing 75,000 square feet of indoor exhibit space and two covered show facilities. The equestrian center covers more than two acres and the livestock pavilion measures 160 feet by 200 feet. Because the grounds are used for many events throughout the year, in 2006, the site was named the Paso Robles Event Center. The current $8 general fair-admission fee permits visitors to view many of the same types of items that were on display at the first fair . . . plus much, much more. (Courtesy Mid-State Fair.)

Six

THE CHANGING HORIZON
DOWNTOWN AND COUNTRYSIDE

This mission bell, on the Spring Street side of the downtown park, marks historic El Camino Real (The Royal Road) on which the Franciscan friars traveled during a day's journey from one mission to the next. The first bell was placed in downtown Los Angeles in 1906, and by 1915, there were approximately 158 bells installed along El Camino Real. The main highway, a section of El Camino Real, came through Paso Robles on Spring Street until the late 1950s, when a freeway skirting the town was built. Because travelers then bypassed the city, some Spring Street motels closed, and new motels were constructed at the junction of Highways 101 and 46. To meet the needs of freeway travelers, restaurants, fast-food establishments, and service stations were also built at that intersection.

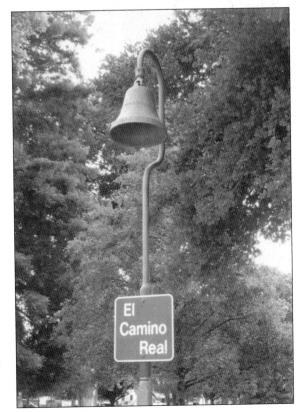

123

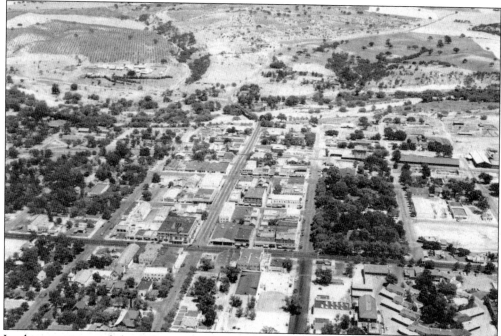

Looking east toward the Salinas River, this photograph shows Fourteenth, Thirteenth, and Twelfth Streets before the freeway was built. Thirteenth Street now crosses the Salinas River on the new four-lane Robert J. Rader Memorial Bridge. At the top left is the almond plant, orchard, and headquarters of the Associated Almond Growers, later Jackson-Reinert. The almond orchards and the bare hills were transformed into homes during the housing boom of the past two decades.

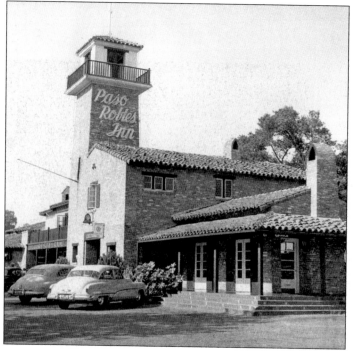

Completed in early 1942 on the site of the earlier 1891 "fireproof" Hotel El Paso de Robles, the Paso Robles Inn incorporated some bricks from the old hotel. Because of the Depression, gas rationing, and modern medicine, though, people no longer flocked to Paso Robles for its healing waters; times had changed. However, in recent years, there has been renewed interest in sulfur springs. On the grand hotel's site, guests are again able to enjoy hot mineral baths in their private rooms, and the historic ballroom has also been restored to its original glory.

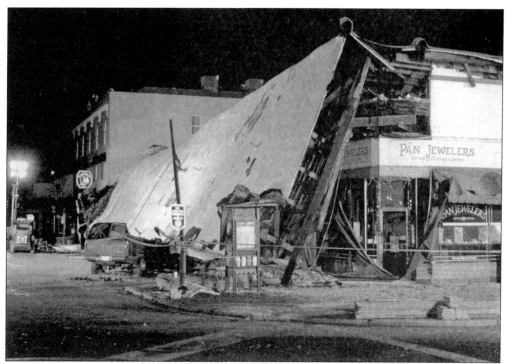

More changes came about after December 22, 2003, when the devastating 6.5 magnitude San Simeon earthquake wreaked havoc on some of the older downtown buildings as well as other commercial buildings and houses throughout the area. Some structures were destroyed, as was this one at Twelfth and Park Streets, where two people died when the roof slid off and landed on top of them. Other buildings were damaged but have been repaired and reoccupied.

In 1882, in the York Mountain area west of Templeton, Andrew York grew grapes, unirrigated, and started a winery—the area's oldest winery in continuous operation. Because of the north county's ideal climate, farmers have continued to plant grapes. In the mid-1990s, there were between 12,000 and 15,000 acres of grapes; now there are approximately 26,000 acres, mostly irrigated. As it has become increasingly difficult for small family farms to survive, agricultural tourism has developed, providing visitors with a variety of experiences, from petting alpacas to picking pumpkins to watching olive pressing.

Although changes are taking place in the town and in the countryside, the Paso Robles Pioneer Museum, at 2010 Riverside Avenue, is dedicated to preserving the special heritage of the area. Displays include items from early-day businesses and homes (above), a collection of Paderewski memorabilia, carriages, wagons, and more. Children (below), visiting the 1886 one-room Geneseo schoolhouse (relocated to the Pioneer Museum grounds in 2004), watch docent Jay Ferrin demonstrate how a quill was trimmed for use as an ink pen. To learn more about the museum, visit www.PasoRoblesPioneerMuseum.org.

INDEX

ACROSS AMERICA, PEOPLE ARE DISCOVERING SOMETHING WONDERFUL. *THEIR HERITAGE.*

Arcadia Publishing is the leading local history publisher in the United States. With more than 3,000 titles in print and hundreds of new titles released every year, Arcadia has extensive specialized experience chronicling the history of communities and celebrating America's hidden stories, bringing to life the people, places, and events from the past. To discover the history of other communities across the nation, please visit:

www.arcadiapublishing.com

Customized search tools allow you to find regional history books about the town where you grew up, the cities where your friends and family live, the town where your parents met, or even that retirement spot you've been dreaming about.

1.66